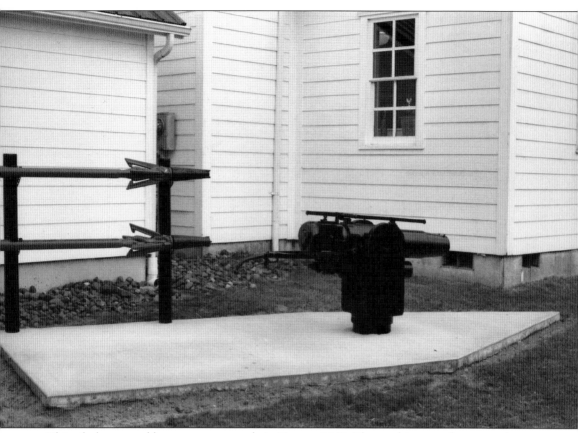

This whale gun and harpoons were made in Norway 1947. The markings on the top read:
 Konsberg
 VApen Fabrikk 1
 1947
 No. 559
The whale gun is located outside the Warrenton-Hammond Historical Society in downtown Warrenton. (Courtesy of Susan L. Glen.)

ON THE COVER: Mr. Hall, Grace McFarland, Anna Bosshart Tetlow, and Mrs. Hall stand in front of the Flavel Hotel off Massachusetts Highway in Flavel, Oregon. The Halls were caretakers of the hotel after it closed. (Courtesy of the Bosshart family.)

IMAGES of America
WARRENTON-HAMMOND

Susan L. Glen and the
Warrenton-Hammond Historical Society

Copyright © 2009 by Susan L. Glen and the Warrenton-Hammond Histroical Society
ISBN 978-0-7385-7160-7

Published by Arcadia Publishing
Charleston SC, Chicago IL, Portsmouth NH, San Francisco CA

Printed in the United States of America

Library of Congress Control Number: 2009930505

For all general information contact Arcadia Publishing at:
Telephone 843-853-2070
Fax 843-853-0044
E-mail sales@arcadiapublishing.com
For customer service and orders:
Toll-Free 1-888-313-2665

Visit us on the Internet at www.arcadiapublishing.com

*This book is dedicated to the determined pioneers
and laborers who settled here.*

Contents

Acknowledgments		6
Introduction		7
1.	Flavel	9
2.	Hammond	21
3.	Warrenton	67

ACKNOWLEDGMENTS

Warrenton-Hammond would not have become a reality without the assistance of many members of the community. Diane Collier, Pat Williams, Charlotte Bergerson, Charles Bergerson, Bob Gohl, John Shepherd, Caroline Shepherd, Bernice Enke and Trudy Enke all provided photographs and stories of the area.

Books consulted for personal memories about the area include *The Adventures of Snooky and Wade* by Wallace Henry Reed, *Making my Way* by Rudolph Terry Shappee, *Warrenton* by Lyle Anderson, *I Remember When* by Charlotte Bergeson, and *Raised by the Sea* by Clarence Sigardson.

INTRODUCTION

The towns of Flavel, Skipanon, Lexington, and Hammond were once viable communities along the Columbia and Skipanon Rivers. Yellow Bank, Sellington, and Fairhaven were also within the area now known as Warrenton. Fairhaven was platted on June 7, 1914, and later vacated on May 14, 1917. The exact location of Yellow Bank has not been determined and Sellington was platted on July 14, 1913, but never vacated. Today they are all part of the 16.7 square miles of land for the town of Warrenton, Oregon, platted in 1889, laid out on a tract of 52 acres in 1891, and incorporated in February 1899. Warrenton, named for D. K. Warren, had the first female mayor west of the Mississippi. The home of Daniel Knight Warren still stands in the town. Daniel K. Warren sent to Illinois for 1,000 sapling trees to be planted in the town. Many of the streets were named for these trees. Some names remain while others have changed over time. The trees that were planted down the main street of town are gone, but a few of the others can be seen throughout the city. A few streets were paved with cement in 1915, others followed sporadically.

Flavel was one of four ports for the Great Northern Steamship line and the site of the Flavel Hotel. Passengers came to stay at the hotel while waiting to board steamships bound for San Francisco.

The ships were also used for troop transports during World War I, and following the war, Flavel faded away. The railroad passed through Flavel, where the tracks divided, providing sidings for the movement of vast quantities of goods both in and out of the port at Flavel. In the area of Tansy Point, three canneries were located: Del Mar Cannery, Hovden Cannery, and Point Adams Packing Company. Only Point Adams Packing Company remains in the area. Del Mar Cannery processed fish livers into vitamins, and Hovden Cannery produced fishmeal for fertilizer. Bioproducts, now Bio-Oregon, located between Warrenton and Hammond is also still in operation. The company conducted whaling from 1961 to 1965, but now recycles fish residuals into feed and fertilizer.

Several railroad companies operated in the area, and their tracks ran from Portland to Astoria and out to Hammond and Fort Stevens through Flavel as well as through Warrenton and south to Gearhart and Seaside. Among them were Astoria and Columbia River Railroad, Astoria and South Coast Railroad and Spokane, Portland, and Seattle Railroad.

Skipanon was located to the south of present-day Warrenton, and Lexington was an eight-block area just north of Skipanon. Both of these towns were located in the general area of the present Warrenton High School. Lexington was the original county seat for Clatsop County until it was vacated on July 6, 1888, and the county seat was moved briefly to Warrenton. The county seat was later moved to Astoria, where it now remains. Lexington became Skipanon until 1913 when it was annexed by Warrenton. Solomon Smith was the first white settler in Lexington. He opened a mercantile store in Lexington. Augustus Leassar Wirt opened the Clatsop House Inn and a grocery in the same area.

Hammond is located near the mouth of the Columbia River. In 1980, the area was listed as Oregon's most northwesterly city. In June 1873, Bartholomew Kindred received the original

donation land grant of 620 acres signed by Pres. U. S. Grant. He and his wife, Rachel, had 12 children. The town was platted and recorded in 1890.

The original name of the town was New Astoria. Andrew B. Hammond was going to build a mill in the area. In 1915, the small town got a post office that was named Hammond Post Office, to honor Mr. Hammond, so the people of New Astoria changed the name of their town to Hammond. The post office is still in operation, but the mill was never built.

Fort Stevens Military Reservation, now Fort Stevens, the second largest state park in Oregon, is next to Bartholomew Kindred's donation land grant at Hammond. The navy dredged a mooring basin in Hammond and the U.S. Coast Guard maintained a lifeboat station there for many years. The National Oceanographic and Atmospheric Administration and the National Marine Fisheries Biological Field Station now occupy the lifeboat-station building. Point Adams Coast Guard Lighthouse stood vigilantly near Battery Russell at Fort Stevens until the extension of the south jetty at Hammond. The lighthouse is gone, but the U.S. Coast Guard is present with their air station at the airport. Lectro, located in a World War II U.S. Navy hanger at the Warrenton-Astoria airport, in Warrenton, builds electric tugs for aircraft.

Today all of these towns are incorporated into the City of Warrenton. Warrenton has just recently undergone further economic growth with the addition of "big box" stores, such as Home Depot, Wal-mart, and Costco, and the launch of a new commuter airline at the Astoria-Warrenton Airport.

One
FLAVEL

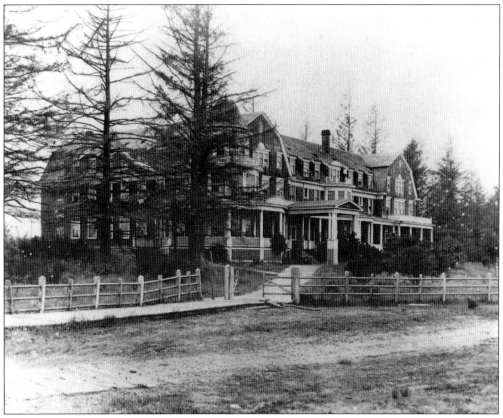

Between the present towns of Hammond and Warrenton, on the site of an old Native American village, the town of Flavel was built as a port to rival Astoria. In 1896 and 1897, the huge, three-story hotel was built. The hotel had an adjoining building with a swimming pool, bowling alley, and saloon inside. A tennis court and riding academy were also on the site. The hotel had its own plant for generating electricity. (Courtesy of Susan L. Glen.)

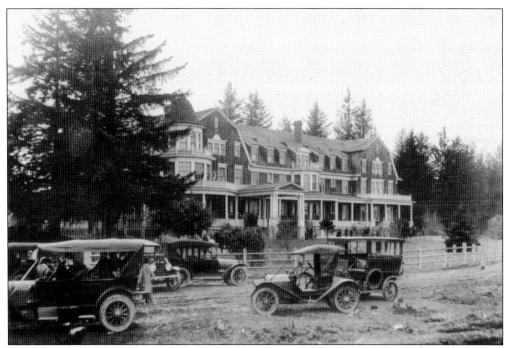

In the 1920s, Warrenton Drive was known as Massachusetts Highway. The Flavel Hotel was located on Massachusetts Highway and was occupied by hundreds of people waiting to board the next ship to San Francisco. The hotel had 90 rooms and a staff of 25. (Courtesy of Susan L. Glen.)

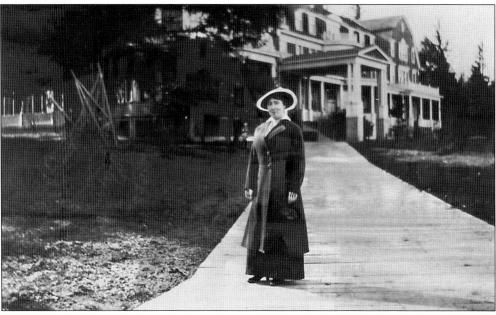

The hotel was razed in 1930. Eight feet of spoils from river dredging cover the area where the hotel once stood. Lumber from the dismantling of the hotel was used to build the Independent Order of Odd Fellow's hall in Warrenton. It is also gone. Nygaard Lumber is located in the area where the hotel once stood. Flavel was annexed to Warrenton in 1918. The population of Flavel in 1915 totaled 30 people. The town was vacated on July 18, 1949. (Courtesy of Susan L. Glen.)

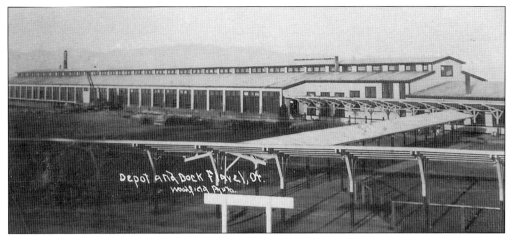

Construction of the docks at Tansy Point, the location of the village of Flavel, began in 1890. Then, following the foreclosure of the hotel in 1906, the rail wharf was condemned. Around 1914, plans were announced to build large terminal docks, and at the same time, construction began on two passenger ships at the Cramp Shipyard on the Delaware River near Philadelphia, Pennsylvania, for use at these docks. James J. Hill of Hill Railway Lines started the service to provide passenger service between the Pacific Northwest and California. (Courtesy of the Warrenton-Hammond Historical Society.)

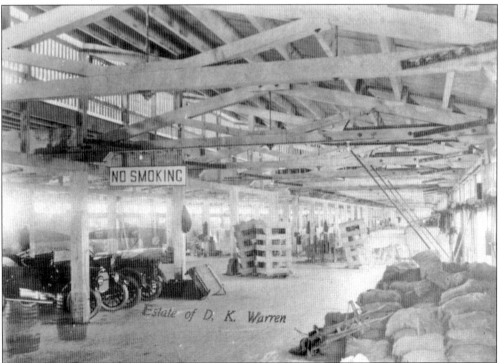

The steamer *Great Northern* departed the day this picture was taken with more than 2,300 tons of freight. The steamer arrived with over 1,100 tons of freight destined for inland ports. Over 75 stevedores were working on the dock that day in addition to the regular dock and boat crews. This picture shows a portion of the interior of the Hill's Dock. (Courtesy of the D. K. Warren estate.)

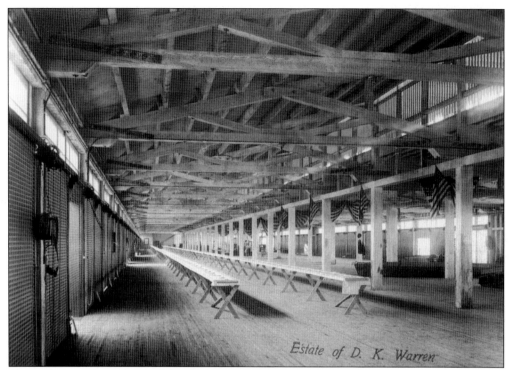
Shown here is the interior of the dock with tables set, awaiting the start of a large gathering. (Courtesy of the D. K. Warren estate.)

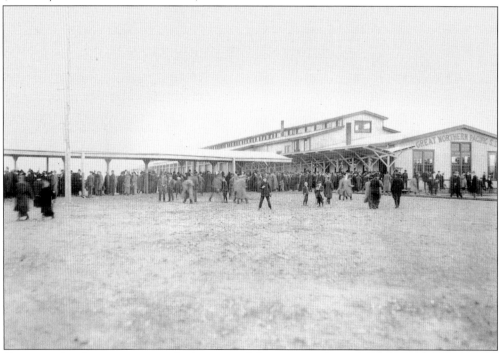
Customers lined up waiting to embark on one of the passenger liners. The ships made three trips per week. (Courtesy of the D. K. Warren estate.)

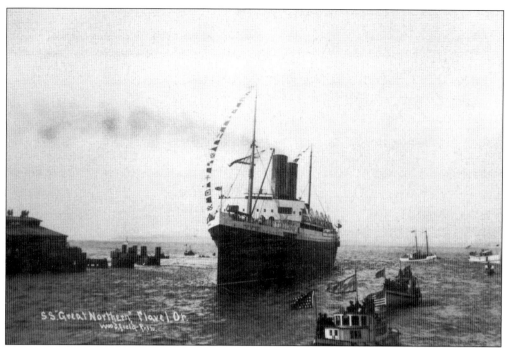

There was a great celebration when the *Great Northern* arrived at Flavel. Many people in the surrounding communities turned out for the inauguration of the steamship service. (Courtesy of Susan L. Glen.)

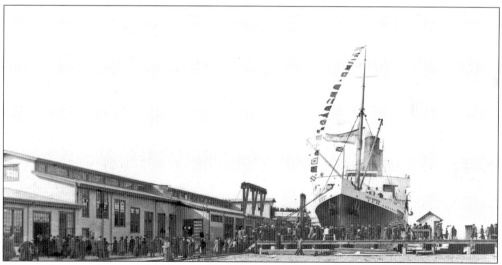

The trip by steamship took 26.5 hours at 23 knots from San Francisco to Flavel. Great Northern Steamship Lines *Great Northern* inaugurated the route on March 16, 1915. The *Northern Pacific* joined on April 17, 1915. The ships were 524 feet long, weighed 12,000 tons, with Parsons turbines to turn three propellers on each ship. Each ship could carry 500 first-class passengers, 198 second class, and 200 third class. They were nicknamed "Twin Palaces of the Pacific." (Courtesy of the Warrenton-Hammond Historical Society.)

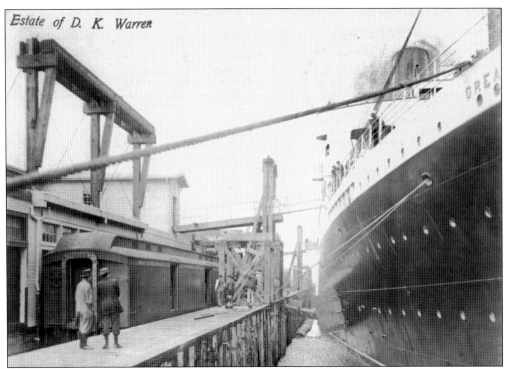

The *Great Northern* sits at the dock alongside train cars. The two ships reported to Bremerton (Washington) Navy Yard in 1917 where they were stripped of their beautiful woodwork and decorations for service as troop carriers during World War I. After the war, the *Northern Pacific* returned to service with the Admiral Line until she caught fire on February 8, 1922, off Cape May, New Jersey. The Admiral Line then bought the *Great Northern*, changed her name to the *H. F. Alexander*, and she continued carrying passengers between the Puget Sound (Washington) and California until 1936. (Courtesy of the D. K. Warren estate.)

At Flavel, the railroad tracks divided into many sidings and lines, as seen here, to accommodate passengers as well as freight trains. The first train from Astoria to Flavel arrived in August 1896, and the line was formally opened in September 1896. (Courtesy of the D. K. Warren estate.)

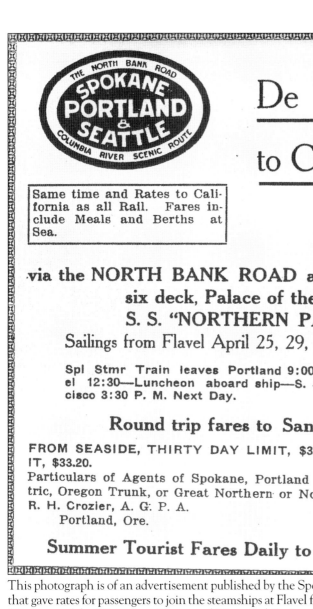

This photograph is of an advertisement published by the Spokane, Portland, and Seattle Railroad that gave rates for passengers to join the steamships at Flavel for sailing to San Francisco, California. (Courtesy of the Warrenton-Hammond Historical Society.)

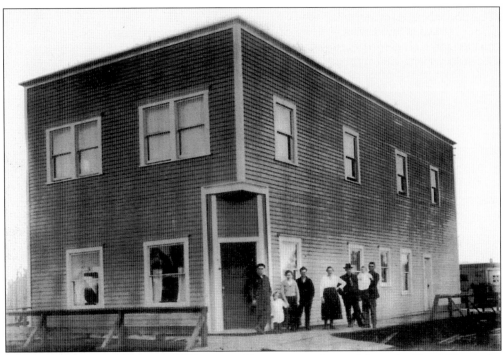

Located at Thirteenth Street and Warrenton Drive, across the road from the Flavel Hotel, the two-story Whistle Inn was built in the early 1920s by Ivar and Mary Vitta. Pictured are, from left to right, Ivar Vitta, Helen Vitta, Mary Vitta, Ivar's brother, Selma Joki, and Gus Joki. The baby and the man holding it are unidentified. The inn was destroyed by fire in February 1923. (Courtesy of Marcella Lindsey.)

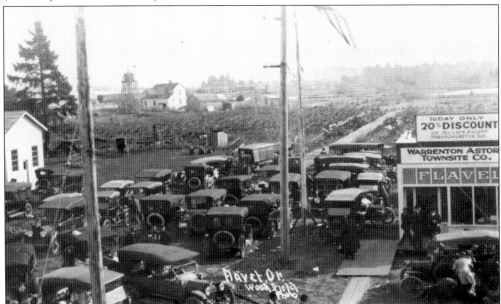

Flavel had a Wells Fargo and Company office, many stores, a barbershop, and a real estate office. The new Flavel post office opened at the Flavel Hotel on June 27, 1897. John Bays was the postmaster. (Courtesy of the Warrenton-Hammond Historical Society.)

Louie Sondberg, standing, talks with Pete Lampa, seated in an automobile in Flavel on December 12, 1943. (Courtesy of the Warrenton-Hammond Historical Society.)

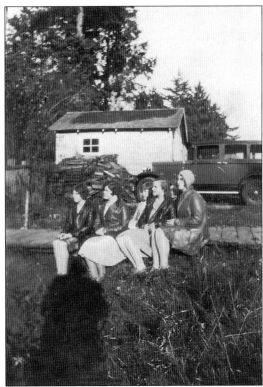

Louise Shaw, Roberta Storm, Ellie Filby, Bernice Enke, and Evelyn ? wait on a log at Flavel. (Courtesy of Bernice and Trudy Enke.)

In this photograph, from left to right, Bernadette, Daniel, and Jeanette Wilson stand outside their house in Flavel in 1916. (Courtesy of the Warrenton-Hammond Historical Society.)

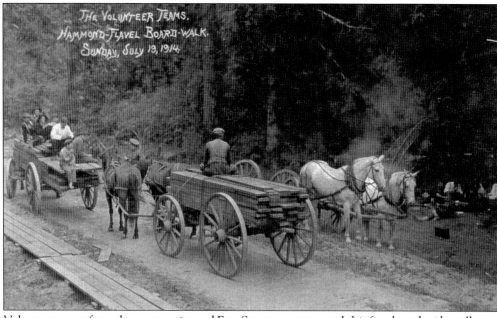

Volunteer teams from the community and Fort Stevens constructed this four-board-wide walkway. (Courtesy of the Warrenton-Hammond Historical Society.)

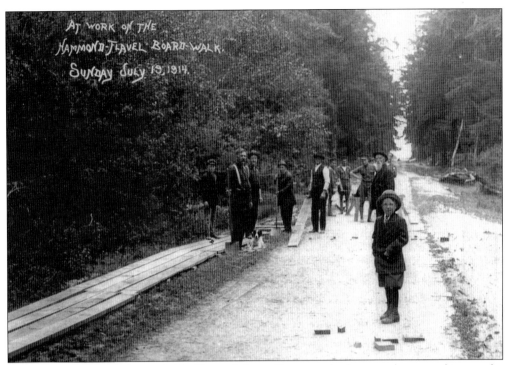

Lewis Falconer, Tom Falconer, Mike Yeager, Johnny Yeager, and others are shown working on the Hammond-Flavel Boardwalk on Sunday, July 19, 1914. (Courtesy of the Warrenton-Hammond Historical Society.)

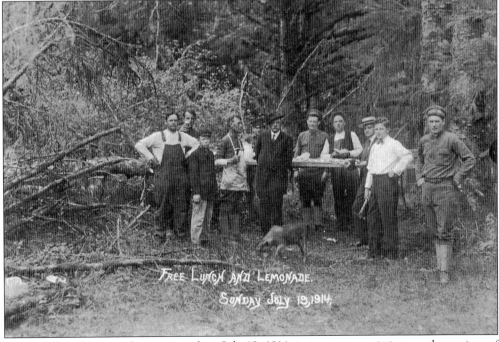

Free lunch and lemonade was served on July 19, 1914, to everyone assisting on the project of building the boardwalk. (Courtesy of the Warrenton-Hammond Historical Society.)

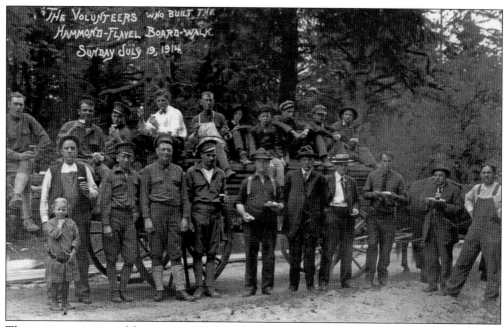

The entire crew stopped for a picture while building the boardwalk. (Courtesy of the Warrenton-Hammond Historical Society.)

Olaf Knutsen built this tree house for his boys, in the area west of Carruther's Park. During World War I, some people thought spies were in the Knutsen tree house. (Courtesy of the Warrenton-Hammond Historical Society.)

Two
HAMMOND

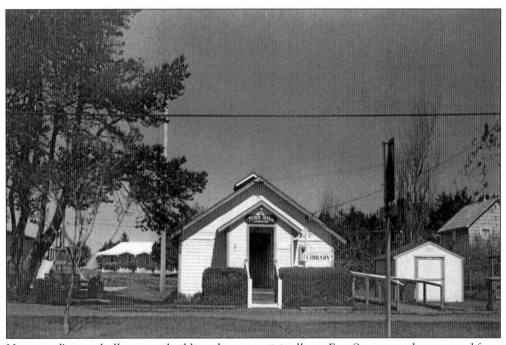

Hammond's town hall was one building that was originally on Fort Stevens and was moved from there onto its current location. The building now serves as the town library. (Courtesy of Susan L. Glen.)

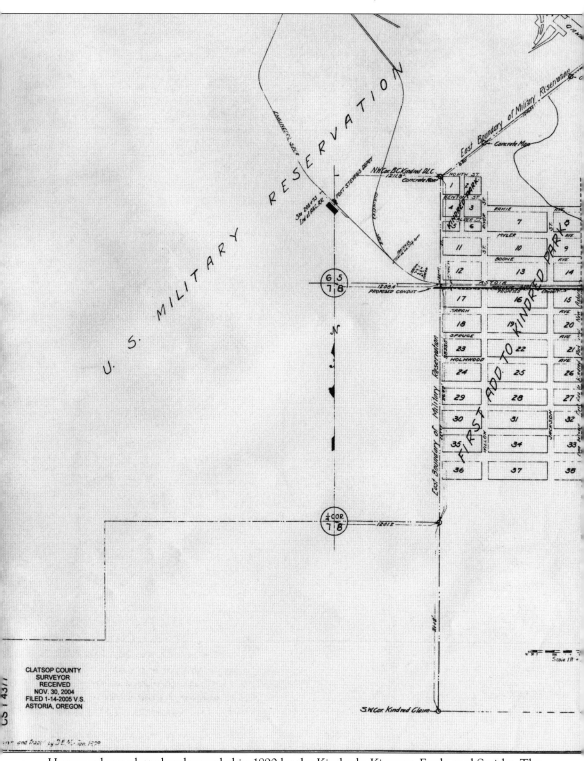

Hammond was platted and recorded in 1890 by the Kindreds, Kinneys, Fords, and Smiths. The town was called New Astoria. C. E. Ford was the first mayor. Most of the original Kindred family

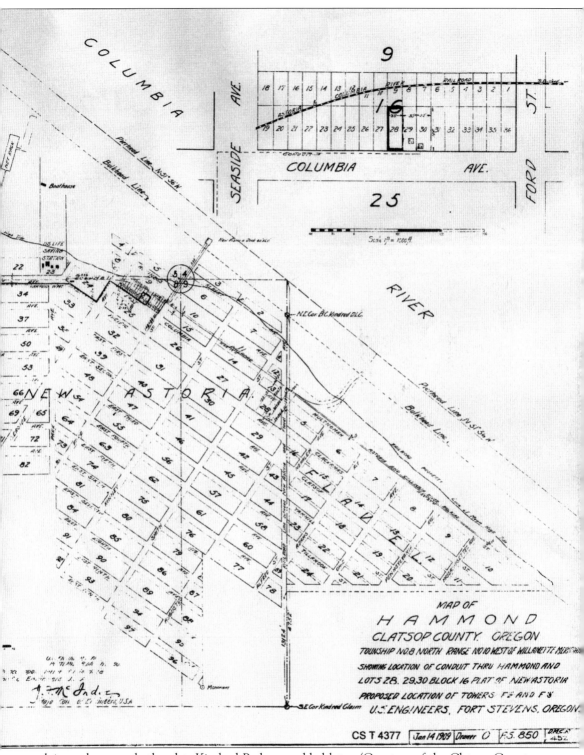

claim to have made the plat. Kindred Park was added later. (Courtesy of the Clatsop County Roads Survey Department.)

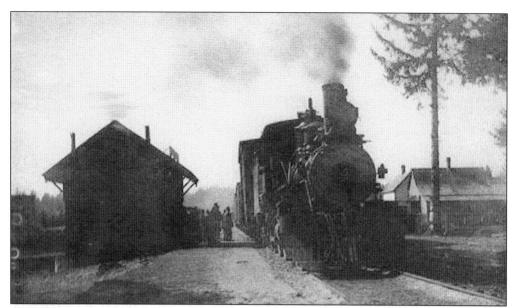

The soldiers at Fort Stevens were often seen getting off the train at the Hammond depot. The tracks went through the center of town. Children put straight pins on the tracks, and the wheels of the train would flatten and weld them into shapes. (Courtesy of the Warrenton-Hammond Historical Society.)

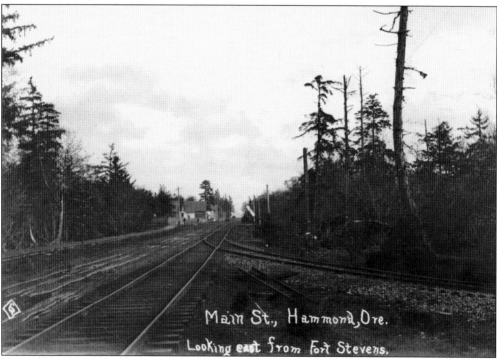

This photograph is of the view to the east from Fort Stevens into Hammond where the railroad tracks divide. One track headed to Flavel and Warrenton while the other went to the south jetty and Fort Stevens. Andrew B. Hammond was the sole owner of the railroad from Gable to Fort Stevens. (Courtesy of the Warrenton-Hammond Historical Society.)

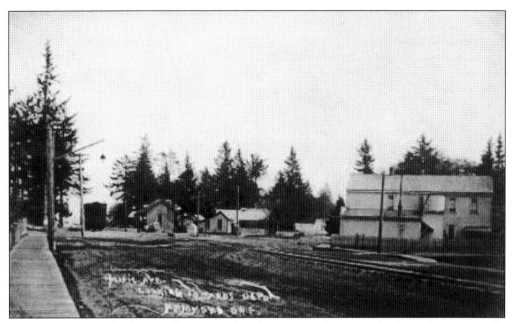

This is a photograph of Main Street, now Pacific Drive, in Hammond, where the train tracks ran, as seen from Fort Stevens. Today the area where the tracks were is a row of trees between two paved streets. (Courtesy of the Warrenton-Hammond Historical Society.)

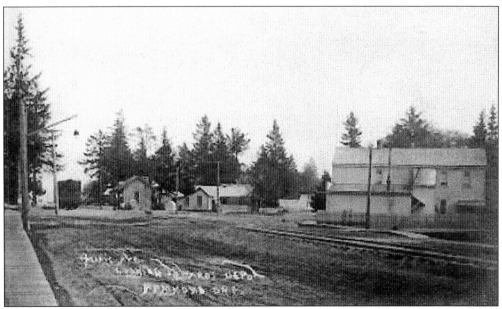

The roads were unpaved and the railroad crossings unmarked. Streets were identified by the names of the people who lived on them until the fire department had a problem identifying where a fire was. (Courtesy of the Warrenton-Hammond Historical Society.)

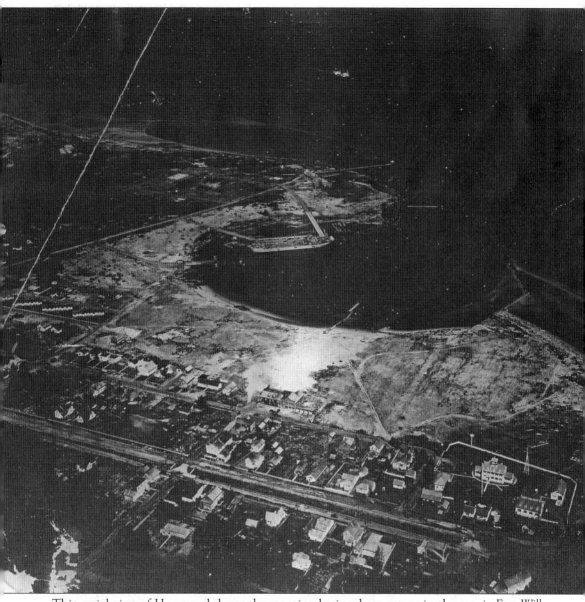

This aerial view of Hammond shows the mooring basin where scenes in the movie *Free Willy* were filmed. In the foreground are, from left to right, the Hammond Dance Hall, Liberty Theater, Cameron's Store, the E. M. Lally Building, Mr. Mudd's Stores, Point Adams, and the mouth of the Columbia River. (Courtesy of the Warrenton-Hammond Historical Society.)

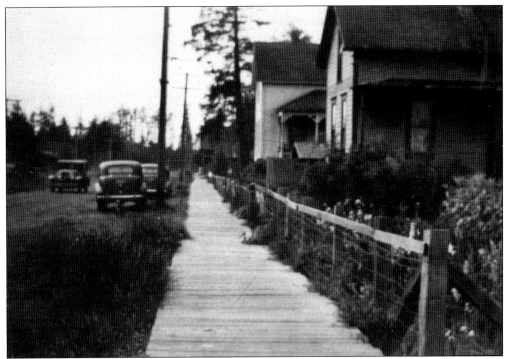

Previously known as New Astoria, with an area known as Kindred Park, the fire station was located at the east end of New Astoria. Many of the original homes are still standing, although the boardwalks are gone. (Courtesy of Susan L. Glen.)

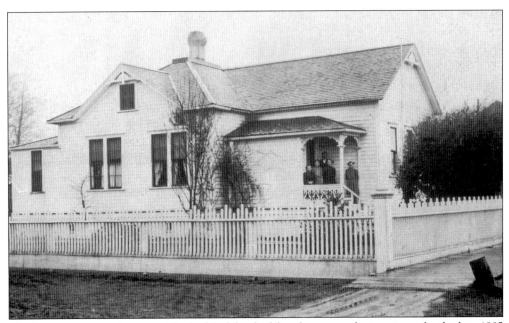

This house in the area known as Kindred Park has had few changes made since it was first built in 1885 in New Astoria. The new family on the porch is unidentified. (Courtesy of Mary McCarty.)

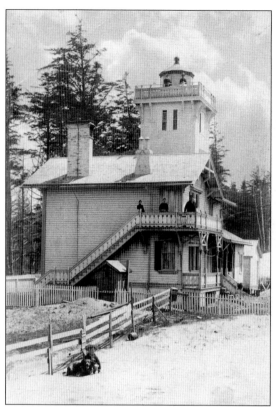

Point Adams Lighthouse was lit on February 15, 1875. It was no longer necessary following the extension of the south jetty and the placing of the Columbia River Lightship to mark the entrance to the river in 1892. The lighthouse was closed in 1899 and demolished in 1912. The lighthouse was actually 1 mile south of Point Adams near the present site of Battery Russell at Fort Stevens. (Courtesy of the Seaside Historical Society.)

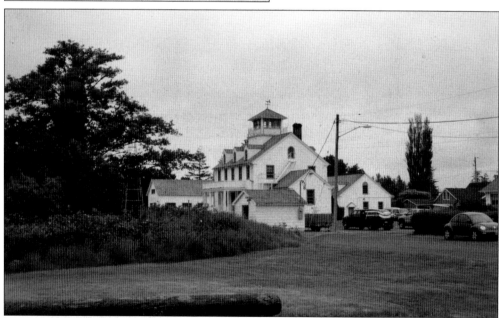

The Point Adams Lifeboat Station is still located along the waterfront, but it is no longer manned by the U.S. Coast Guard. In 1887, Bartholomew Kindred sold a parcel of land to the U.S. government for $200 for use as a life-saving station. The name Point Adams was given by Capt. Robert Gray on May 18, 1792, to honor Pres. John Adams. (Courtesy of Susan L. Glen.)

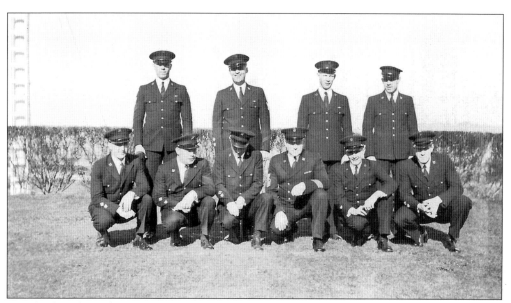

Gottfried Ferdinand Petersen (second row, far left) is shown with the lifeboat crew from the C. G. Lifeboat Station. He was one of the men active in the rescue of the crew of the *Peter Iredale*. (Courtesy of the Warrenton-Hammond Historical Society.)

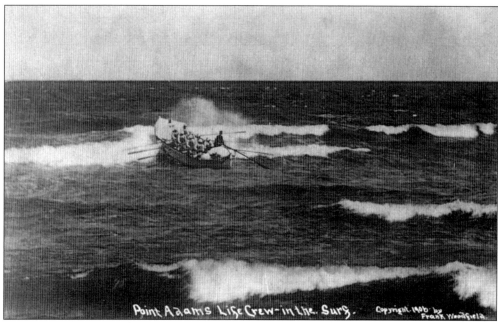

The Point Adams Lifeboat crew guides their boat through the surf off of Hammond. (Courtesy of Bernice and Trudy Enke.)

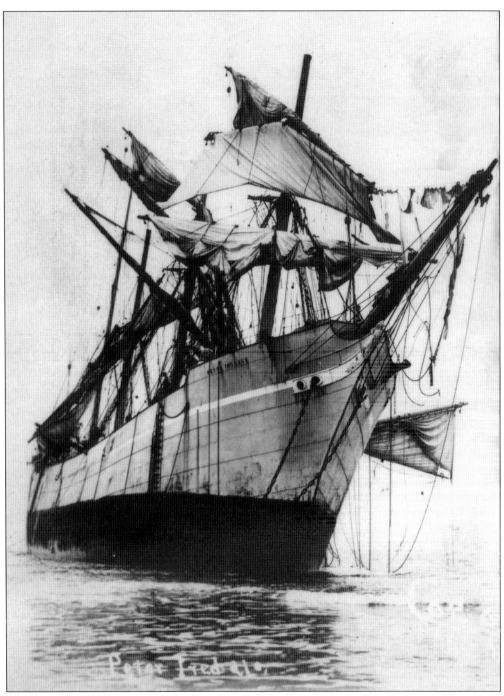

The bark *Peter Iredale* was one of the most famous ships that wrecked off the coast near Hammond. Sections of the hull are still visible on the beach. The 287-foot British sailing vessel went aground on October 25, 1906, but no lives were lost. One story tells that among those rescued was a pig. The pig was taken home by the Storm family along with some of the survivors. The pig staggered on sea legs for a few days until it became accustomed to dry land. Later the pig was fed stale beer from one of the local taverns. (Courtesy of the Bosshart family.)

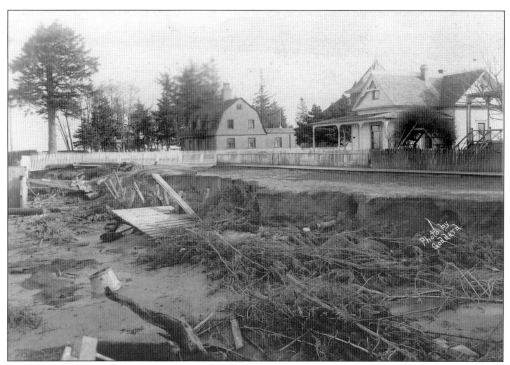

The Rogers, Piersons, and Storms lived along the street in front of the U.S. Coast Guard station. All types of debris were brought up with the changing tide. There was a platform near the station where the children would swim. (Courtesy of Mary McDermott Chase.)

Grandma Storm or Grandma Pierce hung a towel on the clothesline or in the kitchen window to say, "Come over for coffee." Shown here are, from left to right, Louise Shaw, Bernice Enke, Trudy Enke, Roberta Storm, Walter Enke, Arley Jensen, Terry Enke Arnold, and Arlee Jensen. (Courtesy of Bernice and Trudy Enke.)

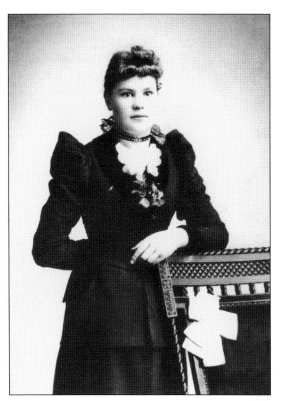

Lena Wirkkla came from Sweden by ship to New York and then by train to Flavel where she worked at the home of Capt. George Flavel and later married Werner Storm. This is her wedding picture. Werner Storm served as a mayor of Hammond. (Courtesy of Bernice and Trudy Enke.)

Werner and Lena Storm dressed to go to the wedding of Don and Louise Shaw. Don and Louise were married on July 18, 1938. (Courtesy of Bernice and Trudy Enke.)

Hammond residents, from left to right, (first row) Roberta Jensen, Ellen Anderson, Ruth Million, Mary Anderson, and Olga Simonsen; (second row) Esther Shea, Bernice Enke, and Louise Shaw took time for a picture. (Courtesy of Bernice and Trudy Enke.)

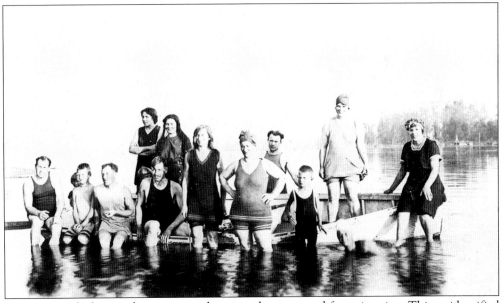

There was a dock near the coast guard station that was used for swimming. This unidentified group of residents posed for a picture while enjoying a sunny day at the beach. (Courtesy of Bernice and Trudy Enke.)

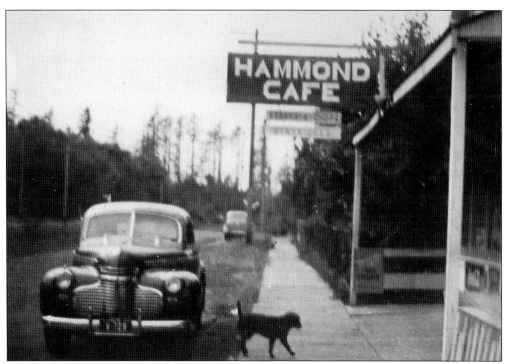

Wooden sidewalks were common throughout the town. This one is shown in front of the Hammond Café. The original Harrison's Grocery on the corner of King Salmon Street and Pacific Drive became Hammond Café. (Courtesy of Susan L. Glen.)

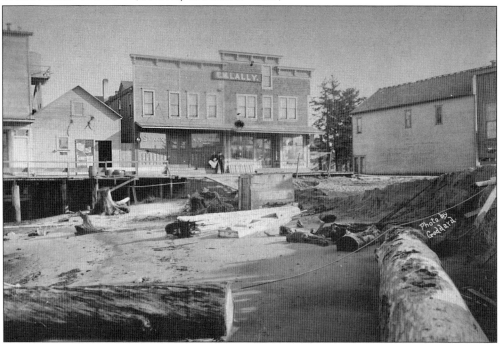

Gray and Kech owned E. M. Lally's store and the building on the right. It was a grocery store that was later moved to Main Street and owned by the Harrisons. (Courtesy of Susan L. Glen.)

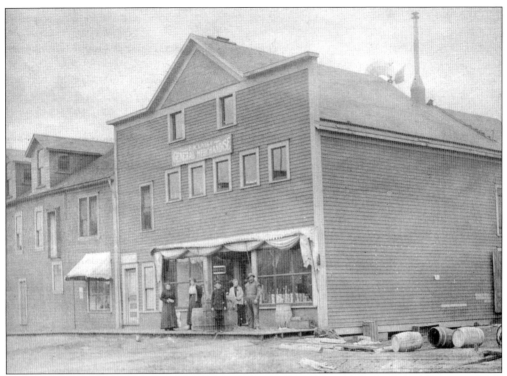

Locations changed as stores were moved, street names were changed, and new buildings were built in New Astoria. This is another picture of the E. M. Lally store. (Courtesy of the Warrenton-Hammond Historical Society.)

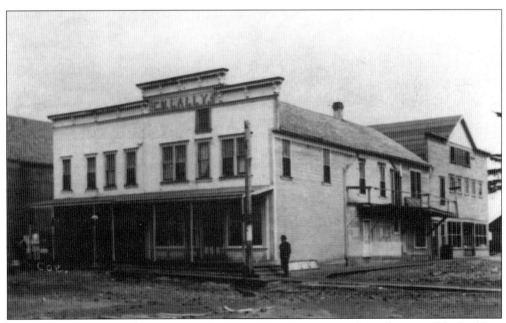

E. M. Lally's store was sold to Don McVey. There were apartments above the store. The building was torn down in the 1960s and replaced by duplexes. (Courtesy of Susan L. Glen.)

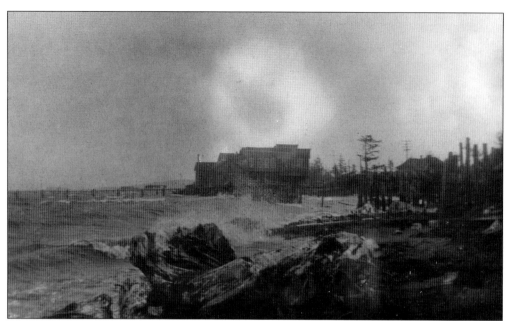

Bob Gray's store was across from Lally's store. The post office was located here. It was a general store and was later purchased by Mr. Parsons. A new store was built later on Main Street. The Columbia River and racks for drying fishing nets can be seen out from the store. (Courtesy of Susan L. Glen.)

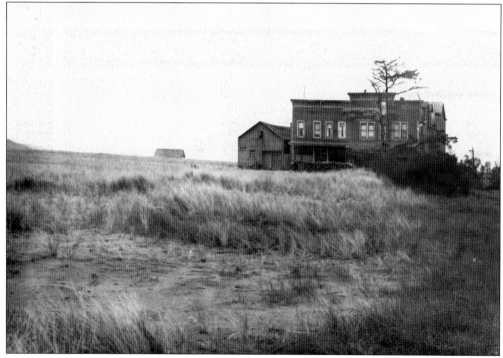

The building in the background is in the water. It was the coast guard boathouse, which disappeared one night in a storm. The building was believed to have been carried out to sea. (Courtesy of Susan L. Glen.)

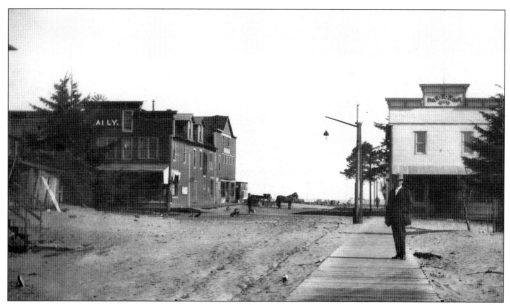

This photograph features the Lally building (left) and the International Order of Odd Fellow's hall (right) in 1911. (Courtesy of Carolyn M. Shepherd.)

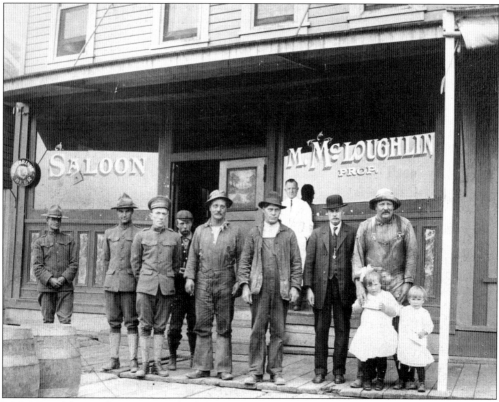

M. McLoughlin's Saloon was on the left of Lally's store. On the far right of the photograph are Werner Storm and his two daughters, Bernice Storm, and Louise Storm. Others are unidentified. (Courtesy of Mary McDermott Chase.)

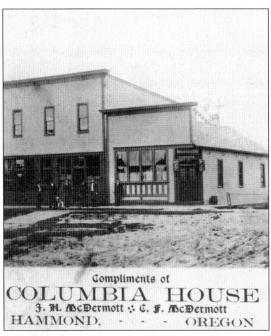

This is an advertisement for Columbia House, compliments of J. H. McDermott and C. F. McDermott. (Courtesy of the Warrenton-Hammond Historical Society.)

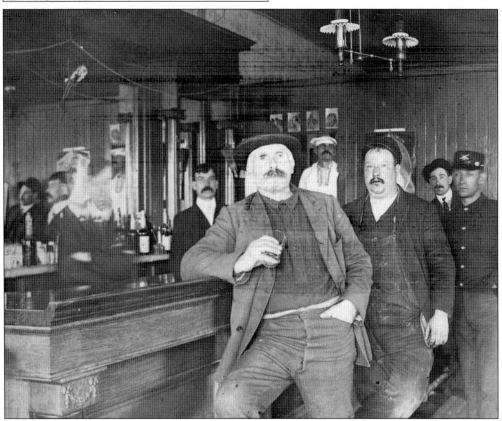

Charles McDermott (left) and Tom Jewett are standing in the foreground at the bar in McDermott Brother's Saloon. The others are unidentified. (Courtesy of Mary McDermott Chase.)

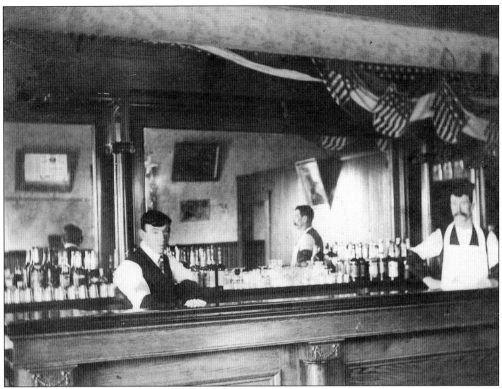

There were two saloons owned by the McDermott brothers. James McDermott is on the left in this picture. The Redman Lodge of the International Order of Redmen also met at the saloon. (Courtesy of Mary McDermott Chase.)

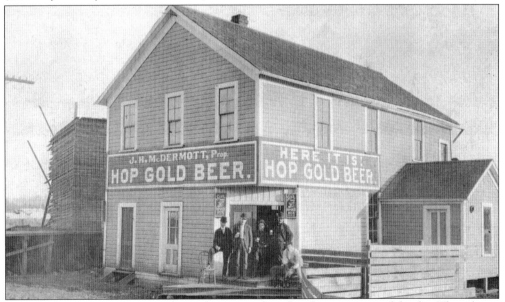

Outside the J. H. McDermott Saloon, the men gathered to discuss events of the day. The saloons were a common gathering place to talk over news, fishing, and other current topics. (Courtesy of the Warrenton-Hammond Historical Society.)

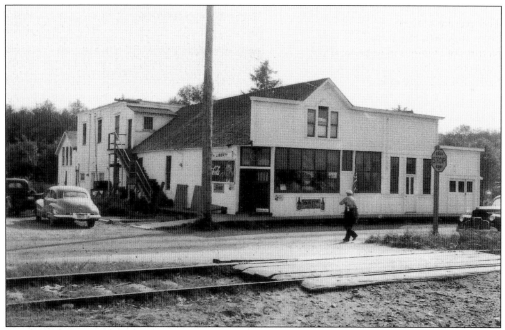

Johnny Ekman owned and ran the Liberty Tavern on the same side of the railroad tracks as the current post office. He sold ice cream at the tavern when it came in from the train. Children were allowed to come in through one door to purchase an ice cream cone for 5¢. (Courtesy of the Warrenton-Hammond Historical Society.)

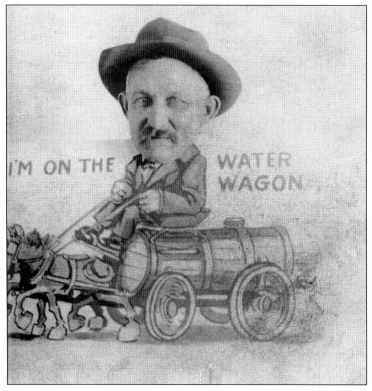

Johnny Ekman is shown here sitting atop a barrel wagon captioned, "I'm on the water wagon." During the years of Prohibition, there were many stills in the area. (Courtesy of the Warrenton-Hammond Historical Society.)

This picture of Bernice Simon Enke, from whom many of the early pictures of Hammond were obtained, was taken in 1930. (Courtesy of Bernice and Trudy Enke.)

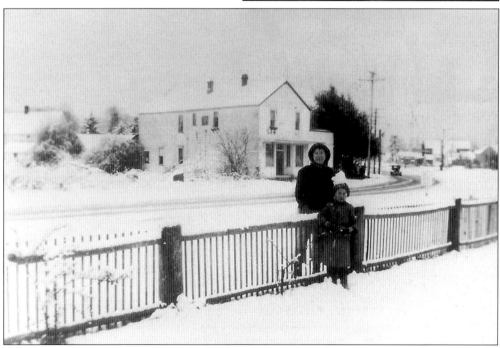

Jennesse Moore Cathers and Glenn Cathers stand along the fence across from Mudd's Store. The Philadelphia Church is now on the site. (Courtesy of Bernice and Trudy Enke.)

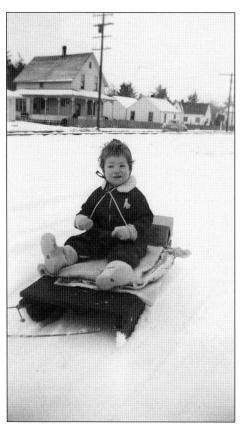

Trudy Enke sits on her sled across from the B. C. Anderson house on Main Street in 1949. The four apartments next to the house were rented out to teachers and others who worked in the community. The Enke family lived in one of the twin houses near the Point Adams U.S. Coast Guard Station. (Courtesy of Bernice and Trudy Enke.)

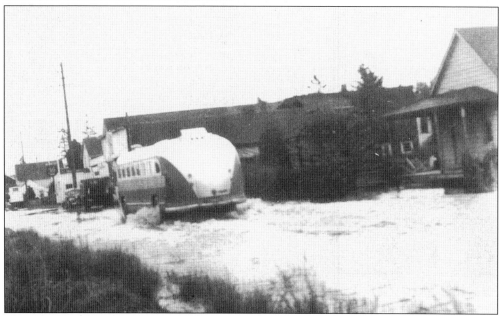

Flooding is not a common experience but even it didn't stop the bus from making a stop in town. The Myers lived in the house on the right. The next building is the Liberty Tavern. The Oregon Motor Stage charged 20¢ for a round trip into Astoria. (Courtesy of Bernice and Trudy Enke.)

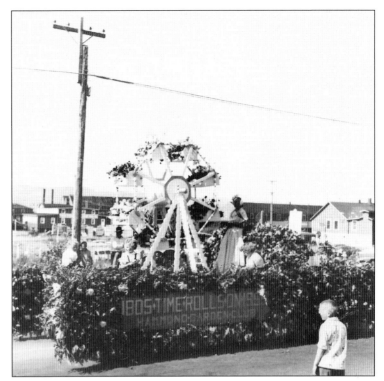

The Hammond Garden Club float for the sesquicentennial parade in Astoria was a Ferris wheel designed by Walter Enke. The flower boxes revolved as the Ferris wheel was motorized. The float won a prize. Walter Enke also served as a mayor of Hammond. (Courtesy of Bernice and Trudy Enke.)

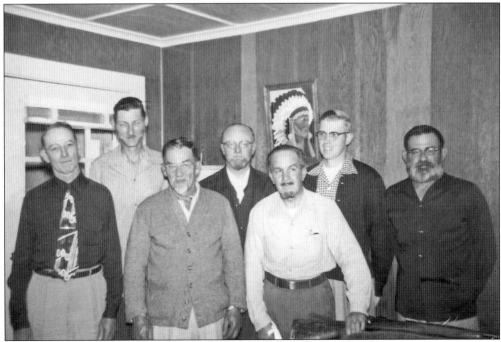

Members of the progressive club grew beards for the Lewis and Clark Sesquicentennial in 1955. In this picture, taken in August 1955 are, from left to right, Jim Cochran, Edwin Mowick, Merton Olney, Werner Holstein, Charles Moore, John Shepherd, and Conrad W. Petersen. (Courtesy of Caroline M. Shepherd.)

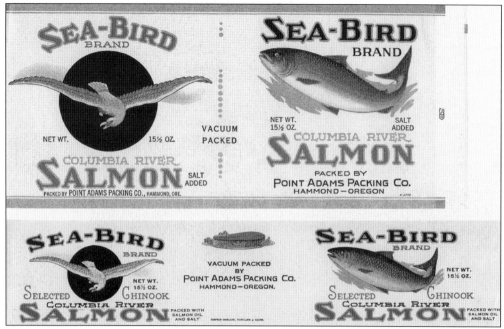

The Point Adams Packing Company, owned by the Rogers and Beard families, is still in operation. These labels are from some of their products. Charles Rogers and Ed Beard started the company. (Courtesy of Cathy Courtwright.)

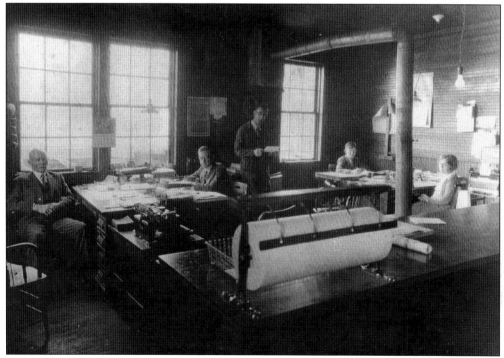

This is a photograph of Point Adams Packing Company office in 1926. Pictured are, from left to right, Tom Nelson, Charles Rogers, Ed Beard, Dick Portwood, and Katie Coffey. (Courtesy of the Warrenton-Hammond Historical Society.)

This is an early picture of the outside of Jim's Canteen. (Courtesy of Susan L. Glen.)

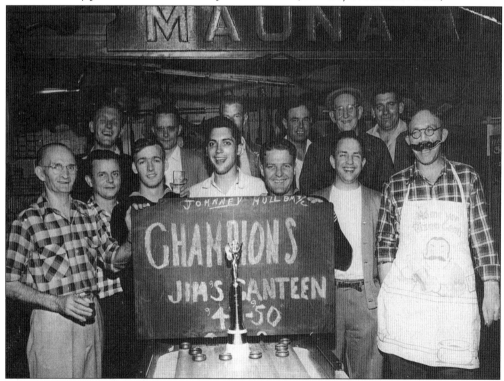

Jim's Canteen in Hammond later became the Buoy 9 restaurant. It was originally located on the opposite side on the street in the Harrison building. The first television sets in town were located here. Pictured are, from left to right, (first row) Pop Wells, Frankie Ericksen, unidentified, Norman Doney, John Hull, Vern Wells, and Harold Broderick; (second row) Bill Broderick, unidentified, Bruce Eastham, Ronald Babb, Jim Ray, and unidentified. The "Mauna" is the signboard off a wrecked ship. (Courtesy of the Warrenton-Hammond Historical Society.)

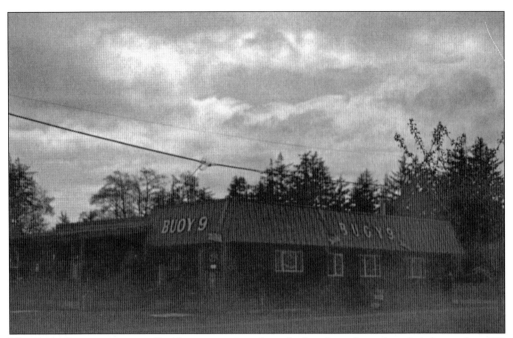

The Buoy 9 restaurant is still a favorite eating place for locals and tourists. It is located at 996 Pacific Drive. (Courtesy of Susan L. Glen.)

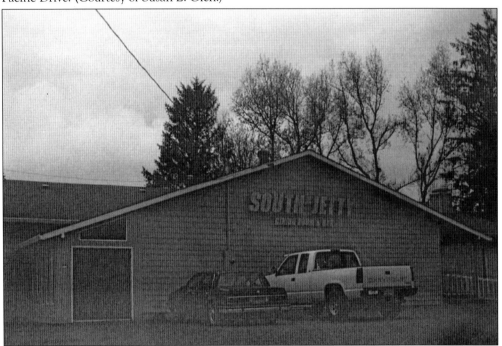

Started by the Mudd brothers, the South Jetty Restaurant was originally the Hammond Dance Hall and a roller rink. During World War I, it served as a United Service Organization, or USO, site and later became Coleman's Restaurant. During World War II, it was divided in half and used by the army and returned to the town following the war to be used as a dance hall again. (Courtesy of Susan L. Glen.)

In 1967, a benefit dance was held at the Hammond Dance Hall to raise money for playground equipment. Pictured are, from left to right, Iduss Heffner, Conrad W. Petersen, "Curly" Larson, Smitty Smith, and Merle Henry. The American Legion also had salmon dinners here. The salmon was stored on ice in the Enkes' bathtub and then cooked in ovens all over town. The money raised was enough to support the organization's projects for the entire year. (Courtesy of Carolyn M. Shepherd.)

The 1920s was the era of "flappers," as reflected by the clothing of the young women in this photograph. From left to right, Bernice Simon, Louise Storm, Roberta Storm, and Eva Wirkkala Hamilton are standing together in front of the Catholic church sometime in the 1920s. (Courtesy of Bernice and Trudy Enke.)

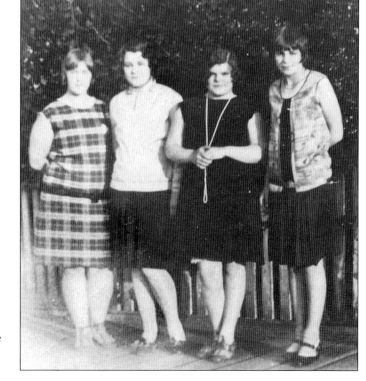

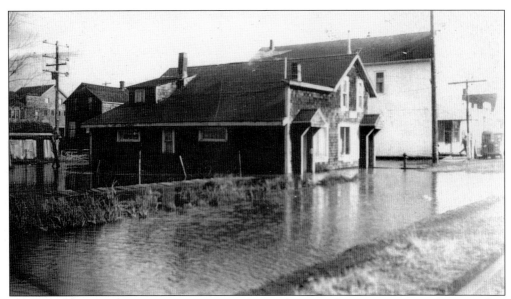

Occasionally Hammond was hit by severe flooding as shown in these two pictures. The post office has water up to the doorstep. The railroad tracks and the road are also submerged. The building on the right is Shaw's Market. Both were located on the north side of Pacific Drive. (Courtesy of the Warrenton-Hammond Historical Society.)

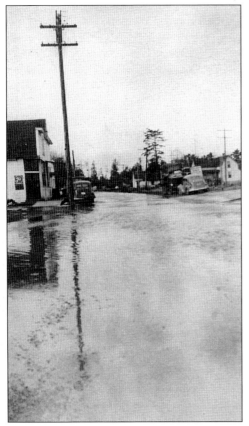

Many of the houses in the area still experience high water during the rainy season. (Courtesy of the Warrenton-Hammond Historical Society.)

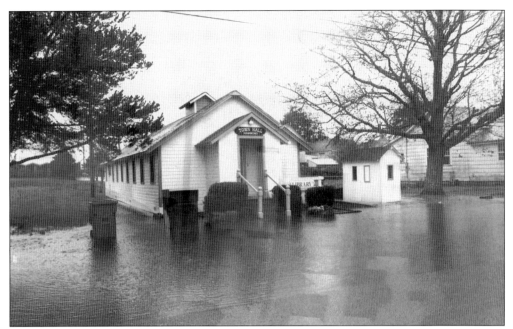

The town hall is shown in this picture during one of the high-water floods. It is now used as the library for the Warrenton and Hammond area. (Courtesy of the Warrenton-Hammond Historical Society.)

Don Shaw owned Shaw's Market from 1948 until 1971. He also had a market in Warrenton for a time. He is seen here sawing a block of ice at his Hammond store. Ice came from the Point Adams Packing Company in 300-pound blocks. (Courtesy of the Warrenton-Hammond Historical Society.)

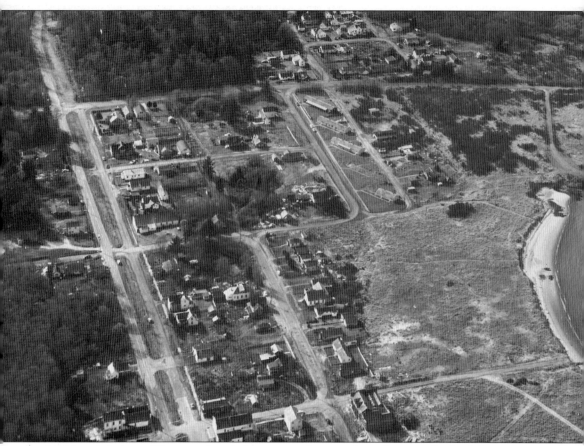

In this aerial view of Hammond and the marina, the site where the navy dredged the mooring basin is pictured and the dredged spoils added many riverfront acres to the town. The mooring basin is a municipal activity, and the boat launch is used by many avid fishermen. The double road on either side of the railroad tracks, which were once there, is visible. The double side road off of

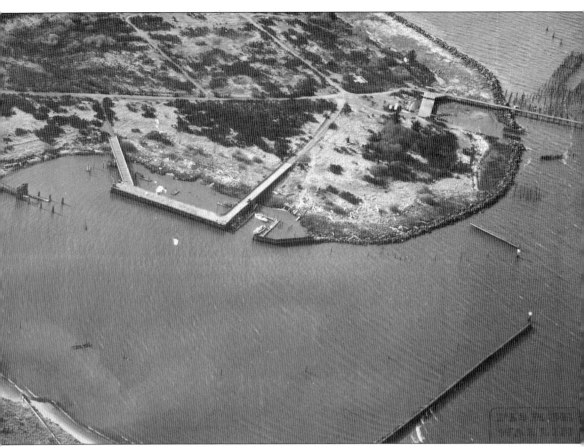

the main road leads to the current fire station. Today there is a large marina in the boat basin, and the docks to the far right are gone. The jetty was recently rebuilt. The two boats in the center were used by the Columbia River Bar Pilots for taking pilots to and from large ships entering the Columbia River over the treacherous Columbia River Bar. (Courtesy of Cathy Courtwright.)

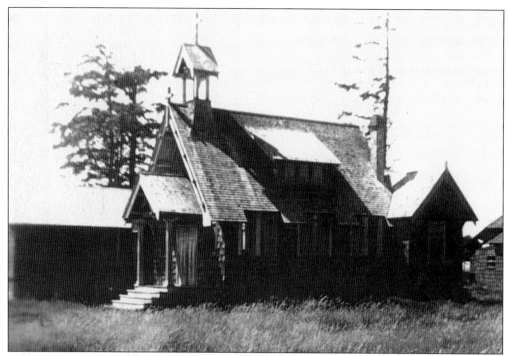

This is a photograph of Hammond Catholic Church prior to being demolished. The church had two Roman crosses, one on the front of the roof and the other on the top of the open belfry. It had cedar shakes on the roof and siding. A new church has since been built. (Courtesy of Bernice and Trudy Enke.)

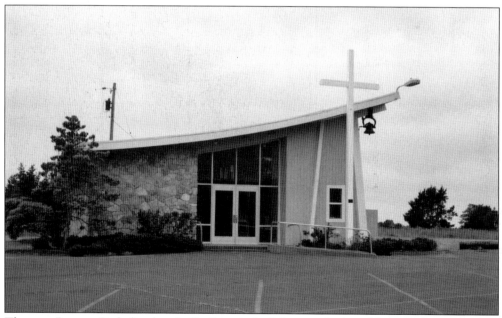

The new Roman Catholic church, St. Francis de Sales, was built in Hammond in 1960. The building was supervised by Reverend Malyszko. (Courtesy of Susan L. Glen.)

The church steeple was removed from Hammond Methodist Church when the building was renovated into a private home. For many years, the steeple remained in another resident's yard. (Courtesy of Bernice and Trudy Enke.)

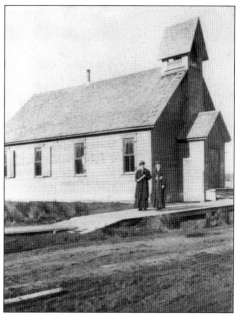

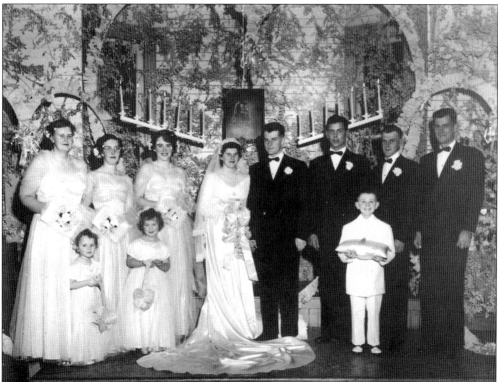

This wedding picture of Jack Olney and Roberta Louise Simonsen taken in January 1950 at the Hammond Methodist Church includes, from left to right, (first row) Arlee Jensen, Trudy Enke, and Bill Shaw; (second row) Delores Simonsen, Zelma Bradley, Jeanette McCormick, Roberta Louise Simonsen, Jack Olney, unidentified, Howard Simonsen, and Clayton McCormick. (Courtesy of Bernice and Trudy Enke.)

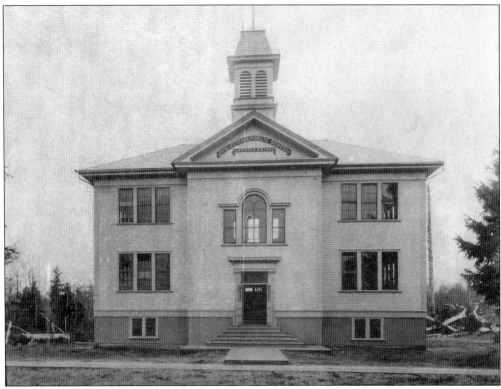

The first school at New Astoria was built in 1893. The railings in the fence around the school were square but were set with the corners up so the children could not walk or sit on the fence. In 1961, the children from Hammond went to school in Warrenton. The grade school at Fort Stevens eventually became a junior high. (Courtesy of the Warrenton-Hammond Historical Society.)

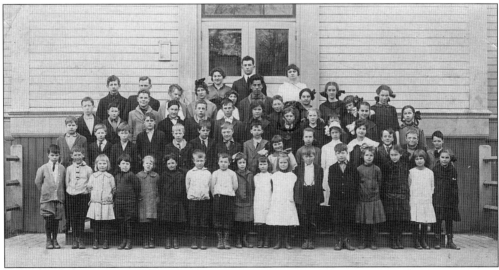

Among the students in this class picture taken in 1915 on George Washington's birthday (February 22) are Blanch ?, Helen Glanz, Hollis Stoddard, two unidentified Keck children, and Harvey ?. Helen Glanz was a teacher at the school. (Courtesy of Susan L. Glen.)

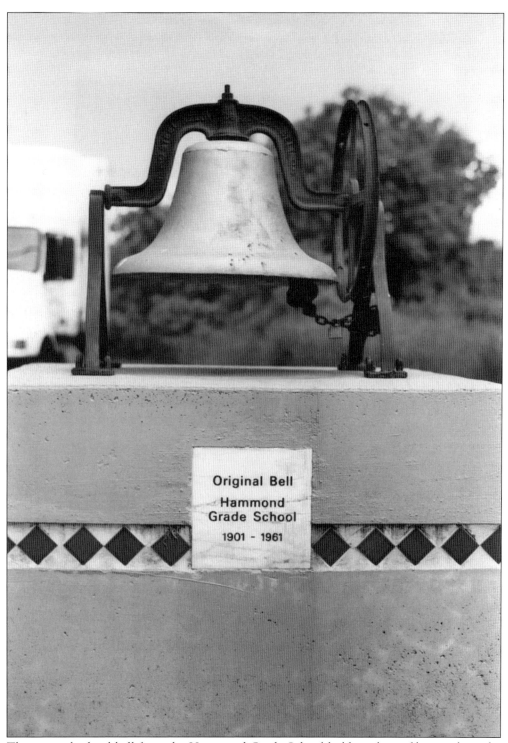

The original school bell from the Hammond Grade School holds a place of honor along the main street in town. The school was on Eighth Street behind the current post office. (Courtesy of Susan L. Glen.)

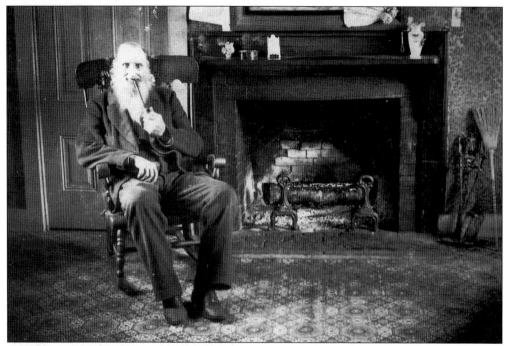

Bartholomew C. Kindred had the original donation land claim of 620 acres. He is shown here in his later years. Many of his descendents are still in the area. (Courtesy of the Warrenton-Hammond Historical Society.)

Three of the Kindred descendants, from left to right, Alec, Ed, and Ralph Kindred, stand together in April 1944. (Courtesy of the Warrenton-Hammond Historical Society.)

Descendants of many of the original settlers still live in the area. Bob Falconer is holding Margey Yeager with Maybel Yeager on his left and Lavern Yeager on the right. (Courtesy of the Warrenton-Hammond Historical Society.)

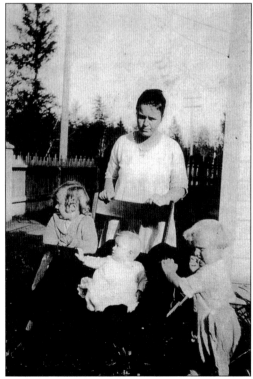

Maybel, Bessie (holding the chair), Margey, and Lavern Yeager are shown on Seventh Street. (Courtesy of Bernice and Trudy Enke.)

This building was constructed but never used, except for a short period when the Hammond Fire Department stored its fire truck on site. Alvin Sampson was the first fire chief. Harold Broderick was the assistant chief and became chief in 1958. (Courtesy of Susan L. Glen.)

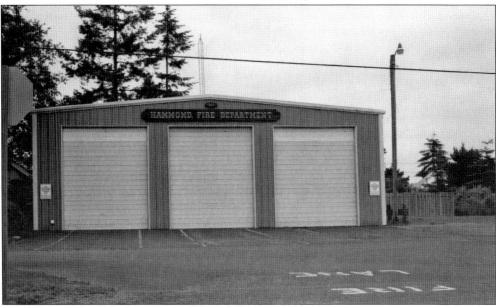

Hammond Fire Station is an all-volunteer fire department. There was an untrained fire brigade in the town for about 15 years. Volunteers purchased a hose and built a trailer that was stored at the Point Adams Coast Guard Station. Around 1949 they organized a fire department. They held a dance and purchased an old building from Fort Stevens and moved it to Hammond for use as a fire station. The building remained the only self-sustained fire department in Oregon until 1955. (Courtesy of Susan L. Glen.)

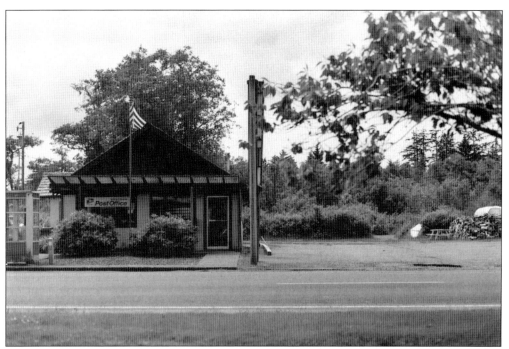

The U.S. Post Office is located on Pacific Way next to the site of the Liberty Tavern. Hammond, although now a part of Warrenton, still maintains a separate post office and zip code. (Courtesy of Susan L. Glen.)

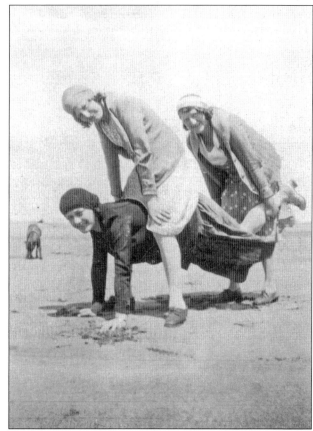

From left to right, Grace ?, Vida Skeels, and Bess Skeels play horse on the beach near the south jetty. (Courtesy of the Warrenton-Hammond Historical Society.)

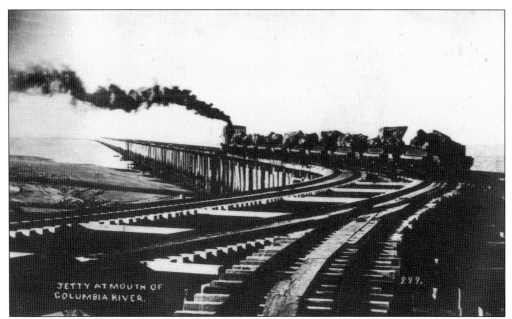

Work began on the building of the jetty at Hammond into the Columbia River in 1884. The jetty was originally 5 miles in length and later extended another 2 miles during the Great Depression. The train carrying rocks crosses the trestle around 1900. There were twin trestles, and the rocks were dropped between them. (Courtesy of the Warrenton-Hammond Historical Society.)

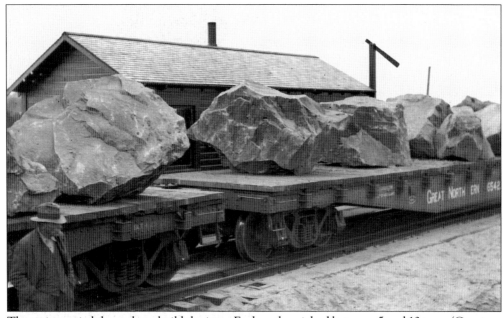

The train carried the rocks to build the jetty. Each rock weighed between 5 and 10 tons. (Courtesy of the Warrenton-Hammond Historical Society.)

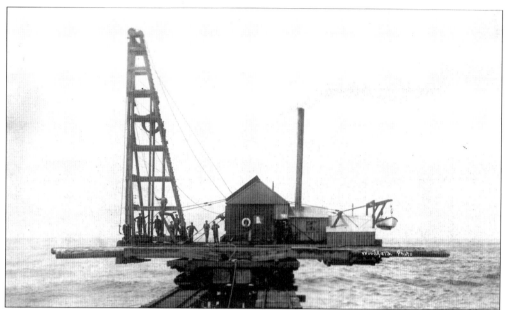

Pilings were driven into the riverbed using this pile driver. (Courtesy of the Warrenton-Hammond Historical Society.)

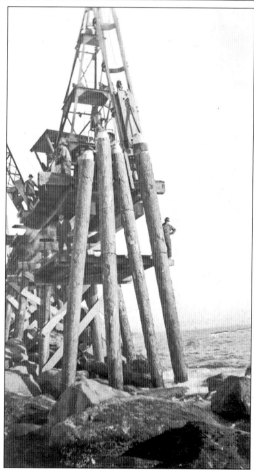

The pilings are under the rocks. The track was built on top, and then the rocks were shoved off the train flatbeds until the jetty was filled. (Courtesy of Carolyn M. Shepherd.)

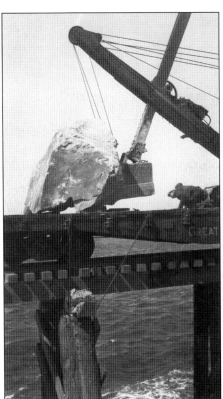

A steam shovel was used to push the huge rocks off the flatcars and into the water. Branches were placed under the rocks to prevent them from being dislodged by the tide and movement of the sand. (Courtesy of Carolyn M. Shepherd.)

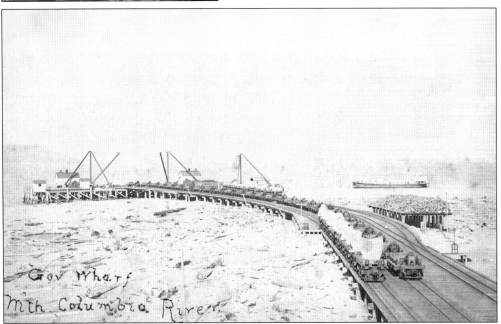

Originally the jetty was to be at low-tide level, but this was altered, and the new jetty plan was modified to be built at high-tide level with four 500- to 1000-foot seawalls at a right angle to the coast on the north side. Later a jetty was built on the north side of the river. (Courtesy of the Warrenton-Hammond Historical Society.)

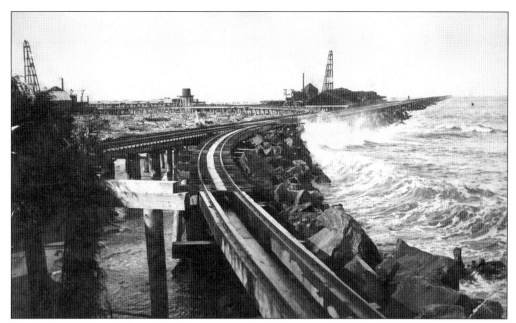

The jetty was reworked in 1982 and again from 2006 to 2008, but this time the rocks were brought in by truck. The south jetty extends from Point Adams to the Clatsop Spit and then 2 miles offshore. (Courtesy of the Warrenton-Hammond Historical Society.)

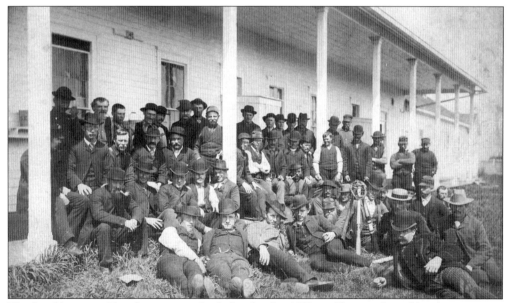

The bunkhouse at Fort Stevens was built for the Civil War soldiers and used by the engineers building the jetty in 1890. (Courtesy of the Warrenton-Hammond Historical Society.)

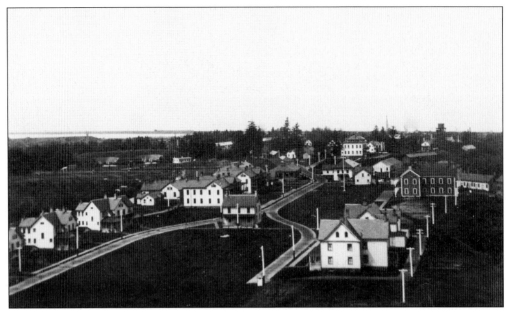

Pictured here is a view of the housing area at Fort Stevens. Some of the houses and other buildings were actually picked up and moved to other locations in Hammond and Warrenton after the military closed the facility. The Town of Hammond annexed an area of 153 acres including the military parade ground, barracks, and officers' residences in 1953. The largest of the barracks was used as a junior high school for a time. (Courtesy of the Warrenton-Hammond Historical Society.)

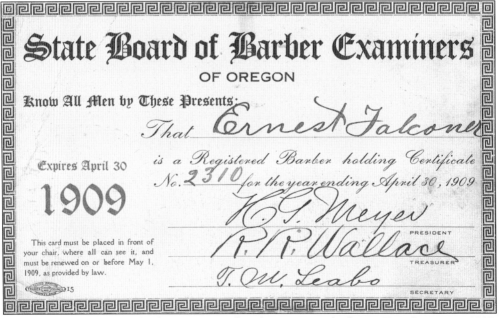

Ernest Falconer was issued a license to conduct business as a barber at Fort Stevens in 1909. (Courtesy of the Warrenton-Hammond Historical Society.)

Louise Soderberg is sitting on top of a cannon that was later removed from Fort Stevens. Carolyn M. Peterson Shepherd stands beside it. (Courtesy of Carolyn M. Shepherd.)

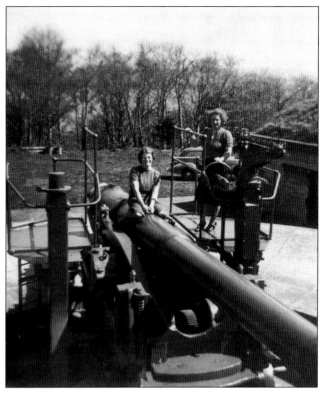

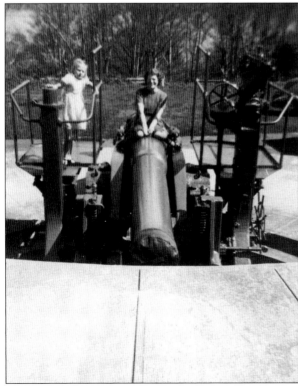

Louise Soderberg is sitting on the same cannon with the daughter of Carolyn M. Peterson, also named Carolyn, on the left. (Courtesy of Carolyn M. Shepherd.)

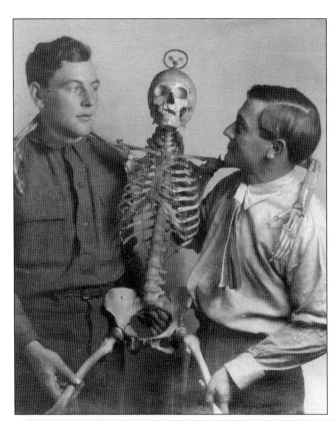

This picture, taken between 1910 and 1912 at Fort Stevens, is of Dowdy and Harris E. with Bessie the skeleton. (Courtesy of the Warrenton-Hammond Historical Society.)

The skeleton of a gray whale that washed up on the beach near Fort Stevens was cleaned and reassembled and put on exhibit near the campground. The skeleton has since been moved to the Seaside Aquarium in Seaside, Oregon. (Courtesy of Susan L. Glen.)

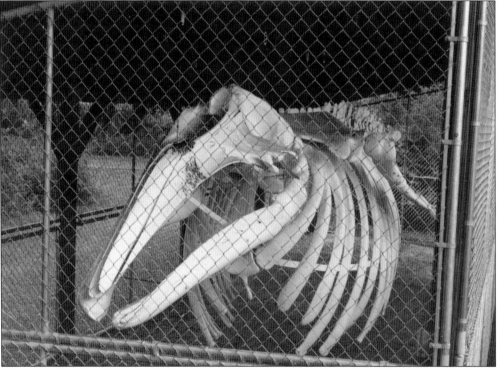

Three
WARRENTON

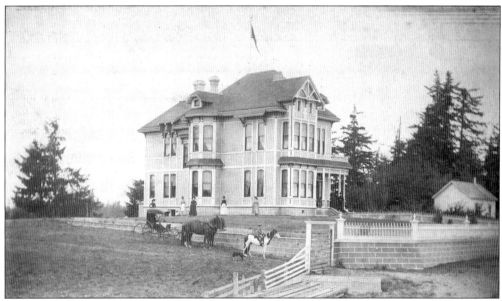

Daniel K. Warren House No. 2 was built in 1885 on the sand ridge that was part of the 1,500 acres secured for the town site. This house was the first in the area to have central heating from a coal furnace. There were no fireplaces in the house. The ceilings in the front and back parlors were painted in oil and gold leaf by an Italian artist. The woodwork throughout the house is black walnut and maple. The house is still inhabited. (Courtesy of the D. K. Warren estate.)

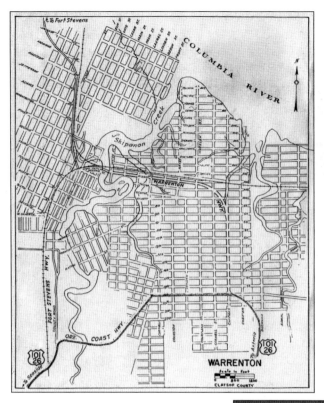

In an article about the town in 1915, there were five industrial plants located on the Skipanon River, many new residences, and electric power and light installations were expected to be completed early in the year. A $150,000 bond issue was authorized to bring pure mountain water from the head of the Lewis and Clark River into the town. The U.S. Highway 101 passed through the town. (Courtesy of the Warrenton-Hammond Historical Society.)

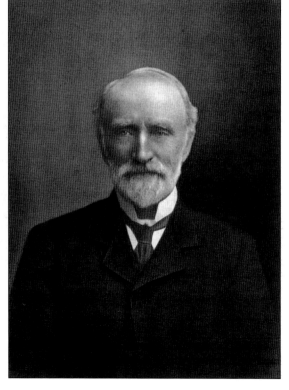

Daniel Knight Warren was the founder of the town of Warrenton. He was born in Bath, New York, on March 12, 1836, and died in Warrenton on November 3, 1903. He and his brother, Phineas C. Warren, came west in 1948. Phineas built his home on the opposite side of the Skipanon. (Courtesy of the Warrenton-Hammond Historical Society.)

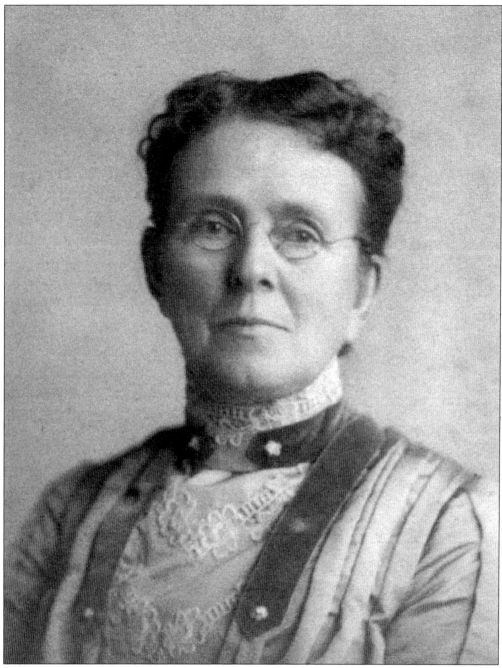

Sarah Eaton Warren was the wife of Daniel K. Warren. She was born on July 28, 1840, in Salisbury, New Hampshire, and married Warren on February 24, 1863. (Courtesy of the Warrenton-Hammond Historical Society.)

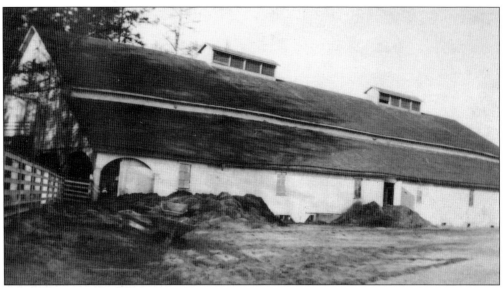

The barn, built on the Warren estate in 1883, was the largest barn in Oregon for 40 years. The barn was three-stories high and had room for 185 cattle. Warren bought cattle at The Dalles, herded them to Portland, and brought them by boat to Warrenton for fattening and butchering. (Courtesy of the Warrenton-Hammond Historical Society.)

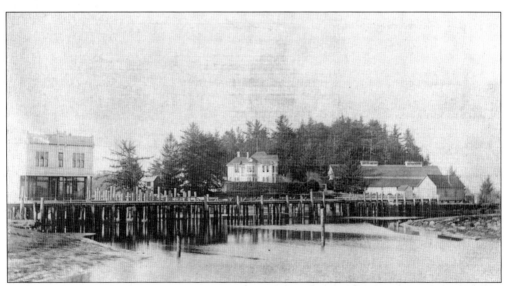

This is the view of the Warren residence and the big barn from the other side of the Skipanon River in 1940. A hilltop burial ground known as the Point holds the remains of D. K. Warren and his wife, Sarah Eaton. The building on the opposite side is Warren's Hall. It was originally a hotel with a lounge and dining room on the first floor and rooms on the upper floor. (Courtesy of the Warrenton-Hammond Historical Society.)

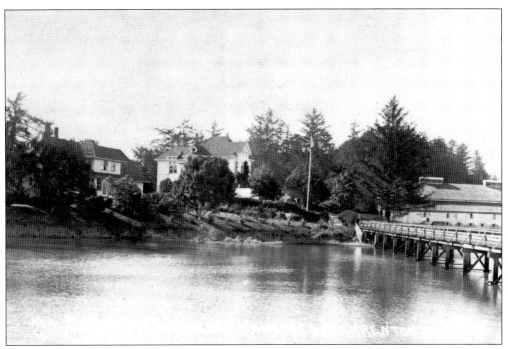

Three houses were actually built on the Warren estate. Seen here with the barn are the second and third houses. The first house was the cookhouse. It was moved to make room for the second house, which was a larger house. (Courtesy of the Warrenton-Hammond Historical Society.)

The cookhouse was the first house on the Warren estate. It was built in 1870 on the site where Chief Toastum, of the Flathead tribe of the Clatsop, had his dwelling in 1865. The house has been moved twice since being built. (Courtesy of the Warrenton-Hammond Historical Society.)

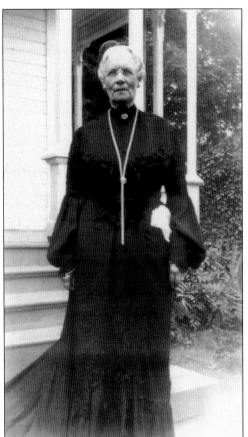

This photograph shows Florence E. Baker Warren, wife of George Wright Warren and daughter-in-law of D. K. Warren, in the long black dress she wore for the Lewis and Clark Sesquicentennial. She was the daughter of Charles G. A. and Ruth Baker. (Courtesy of the Warrenton-Hammond Historical Society.)

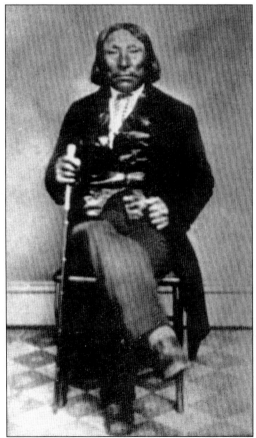

Chief Toastum signed the treaty at Tansy Point on August 5, 1851, that ceded the land on which Warrenton was built to the U.S. government. (Courtesy of the Warrenton-Hammond Historical Society.)

Yel U Hata, Chief Toastum's wife, was the mother of Kate Jurhs. In 1851, she was living at Fort Stevens. (Courtesy of the Warrenton-Hammond Historical Society.)

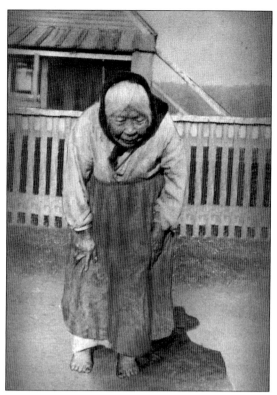

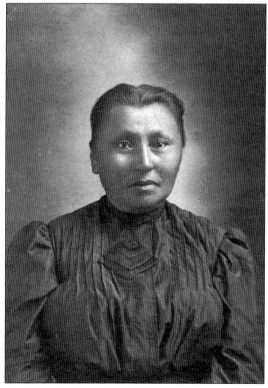

Kate Jurhs, a member of the Clatsop tribe who was born at Fort Stevens in 1851, was the daughter of Chief Toastum. She worked at the Warren's home. She married August Jurhs and was the great-grandmother of Diane Falconer Collier. (Courtesy of the Warrenton-Hammond Historical Society.)

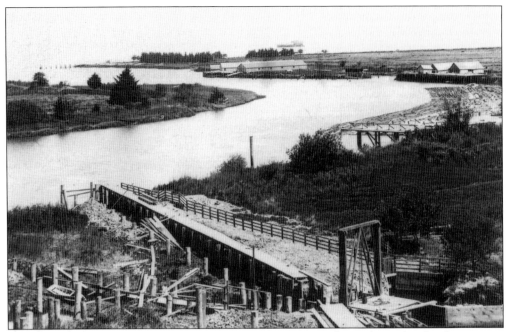

The name *Skipanon* means winding like a snake. In 1925, a channel was dug for the purpose of rafting logs. A boat-building company was located on the other side of the Skipanon River. (Courtesy of the Warrenton-Hammond Historical Society.)

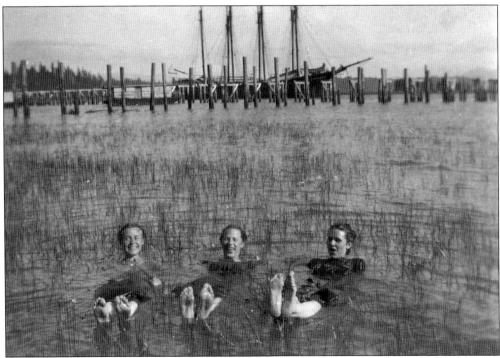

In this photograph, three unidentified ladies are floating in the Skipanon River on a warm afternoon. (Courtesy of the Warrenton-Hammond Historical Society.)

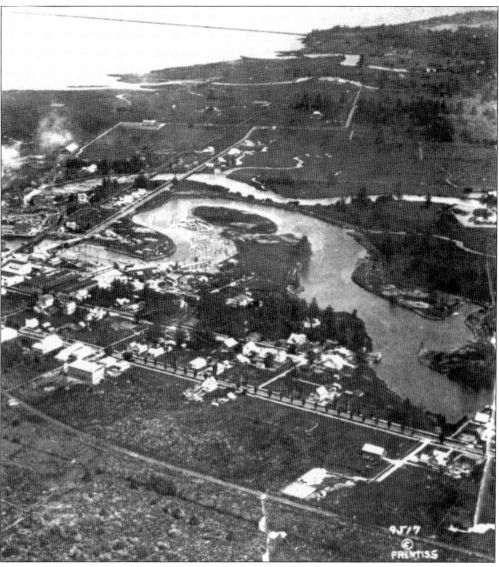

This aerial view of Warrenton and the Skipanon River shows how the river twists. Chinese workers were brought in by Warren to build a 2-mile dike along the river as protection against flooding. There was an island in the river with a sandy beach where children went to swim. It was called the frog pond and was only accessible by walking across the logs in the log rafts in the river. The frog pond was upstream from the Skipanon Bridge. Drainage ditches were also built down river towards Hammond, and a pea farm was begun. The pea farm continued for about two years until a leaf-blight occurred. (Courtesy of the Warrenton-Hammond Historical Society.)

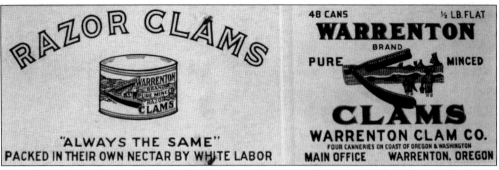

Warrenton Clam Company was located near today's marina site. Carter's Clam Cannery was also located at Skipanon Landing. This is a picture of the end of a box used for shipping its product. The company closed at the end of World War I. (Courtesy of the Warrenton-Hammond Historical Society.)

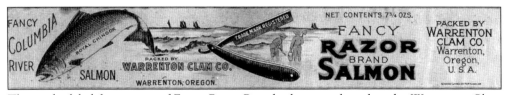

This is the label from a can of Fancy Razor Brand salmon packaged at the Warrenton Clam Company. (Courtesy of Diane Collier.)

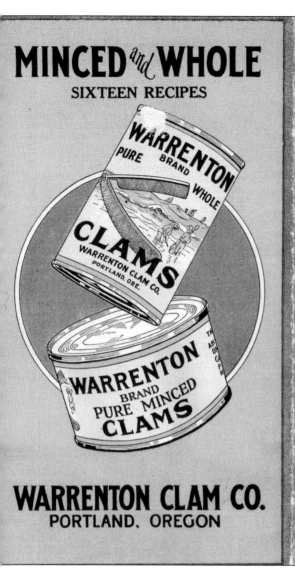
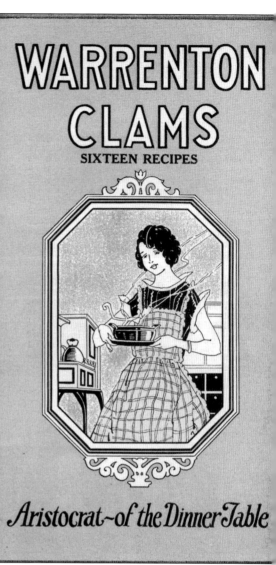

The Warrenton Clam Company printed a 16-page recipe booklet that gave some history of the company and recipes for cooking the clams. (Courtesy of Diane Collier.)

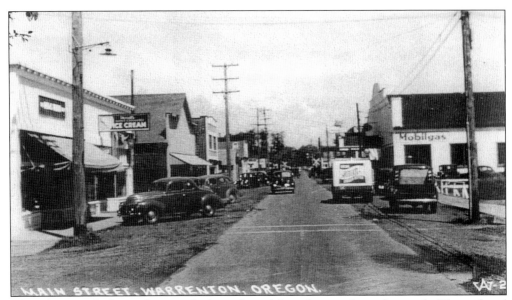

This photograph shows the view looking down Main Avenue from the south. The railroad tracks crossed at the northern end of the street. (Courtesy of the Warrenton-Hammond Historical Society.)

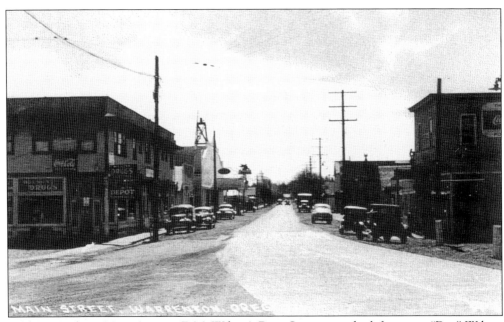

Looking south on Main Avenue, F. M. Wilson's Drug Store is on the left corner. "Doc" Wilson came to town in 1914 and opened his drug store. There was a fountain on the right side of the store with a big mirror behind it. There were also tables and chairs to sit at while eating ice cream in the store. (Courtesy of the Warrenton-Hammond Historical Society.)

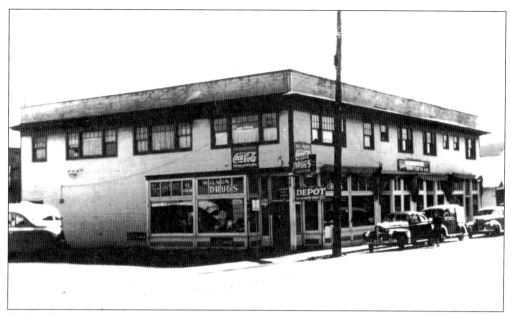

Wilson Drugs was a stop for the bus. Note the depot sign and the bus parked alongside the store. The Oregon motor-stage bus company charged 20¢ round-trip from Warrenton to Astoria. In 1946, "Doc" Wilson bought a new Pontiac and was taking his test for his driver's license. He put the car into reverse, let out the clutch, stepped on the gas, and backed his car across both lanes of traffic into the firewood sales office across the street. He never drove again. (Courtesy of the Warrenton-Hammond Historical Society.)

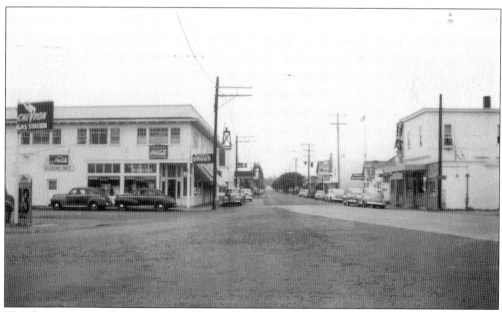

This later picture of the same area shows the Club on the right. A Mexican restaurant now occupies the corner. (Courtesy of the Warrenton-Hammond Historical Society.)

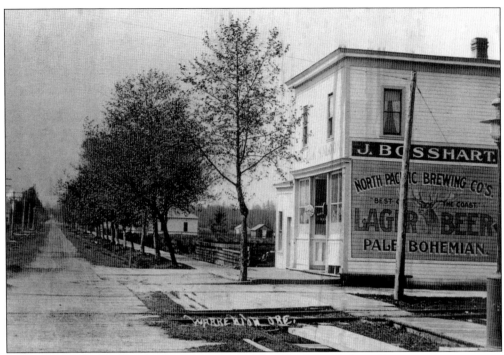

Pictured here is the side of the Elk Saloon advertising North Pacific beer. Painting advertisements directly on the sides of businesses were a common occurrence at the time. The business was first constructed in 1899. (Courtesy of the Bosshart family.)

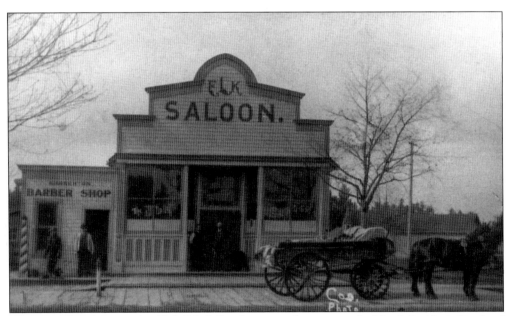

Elk Saloon later became the Club. Jakob Bosshart was a brewmaster for North Pacific in Portland and came to Warrenton. He originally emigrated from Switzerland. He also had a blacksmith shop in the back. (Courtesy of the Warrenton-Hammond Historical Society.)

This neon sign for the Club now belongs to the Warrenton-Hammond Historical Society. Half the town came to watch it being erected. Many had never seen a neon sign. (Courtesy of the Warrenton-Hammond Historical Society.)

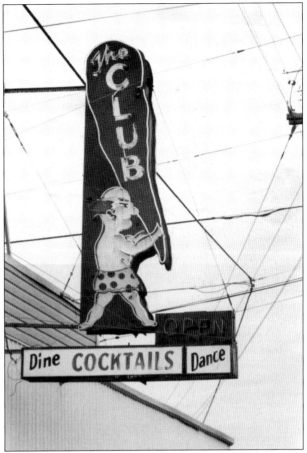

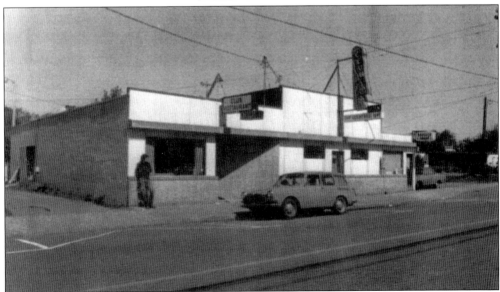

The Club was located at 119 Southeast Main Street. (Courtesy of the Warrenton-Hammond Historical Society.)

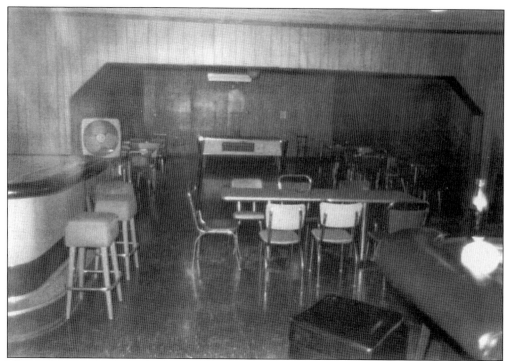

This is the interior of the Club. (Courtesy of the Warrenton-Hammond Historical Society.)

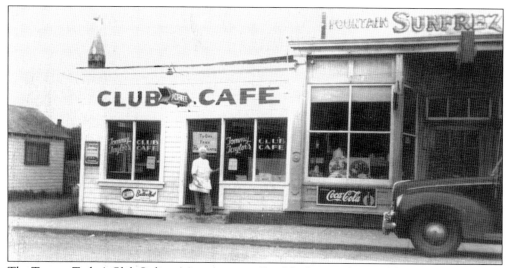

The Tommy Taylor's Club Café on Main Avenue offered fresh razor clams. Although two businesses were at the location in this picture, it was all one building, which became the Club as seen in the previous pictures. At one time, there was also a barbershop at this location. (Courtesy of the Warrenton-Hammond Historical Society.)

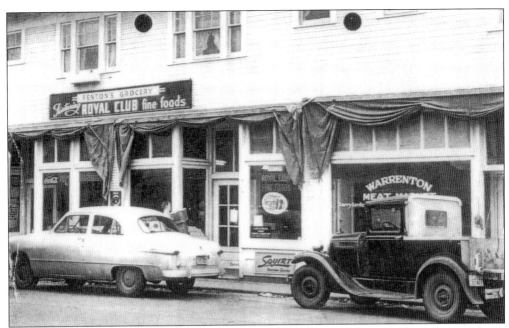

Farther down Main Street was the Warrenton Meat Market and Fenton's Grocery. C. Nasser was the proprietor of the Warrenton Meat Market. (Courtesy of the Warrenton-Hammond Historical Society.)

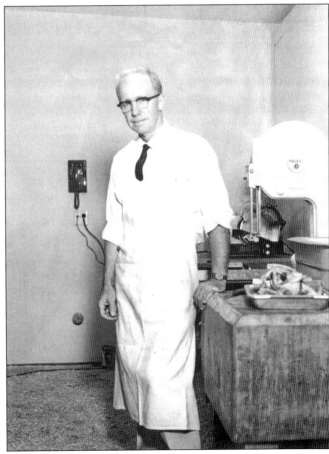

Ames Fenton owned and operated Fenton's Grocery during the 1930s through the 1950s. (Courtesy of the Warrenton-Hammond Historical Society.)

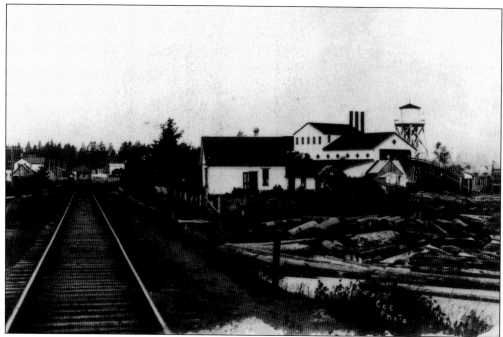

Old Warrenton Mill, known earlier as the Smiley-Lambert Mill, began between 1901 and 1902 by D. K. Warren in association with F. W. Preston and G. B. Hegardt of Astoria. Warren died in 1903, and the mill was purchased and completed by Edmund F. Smiley and Jacob Lambert. Later it was leased by William Tremblay and renamed the Warrenton Mill. Warren had advertised lumber from a sawmill at Warrenton as early as 1891. (Courtesy of the Warrenton-Hammond Historical Society.)

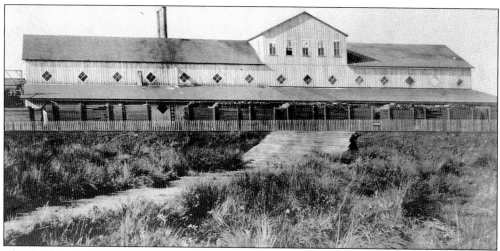

The Smiley-Lambert Mill was located approximately where the Warrenton Marina is today. (Courtesy of the Warrenton-Hammond Historical Society.)

Clara "Carrie" Munson was elected mayor of Warrenton on December 18, 1912. She was the first woman mayor west of the Rocky Mountains and served for one year. Clara's father was the last lighthouse keeper at Point Adams Lighthouse. Clara was a schoolteacher and served as the director of the Warrenton school district for 35 years. (Courtesy of the Warrenton-Hammond Historical Society.)

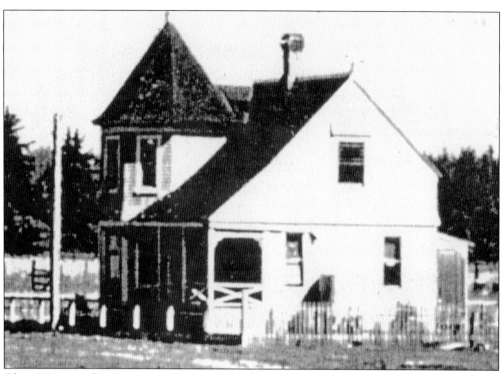
Clara Munson's house on East Harbor Drive is still standing. (Courtesy of the Warrenton-Hammond Historical Society.)

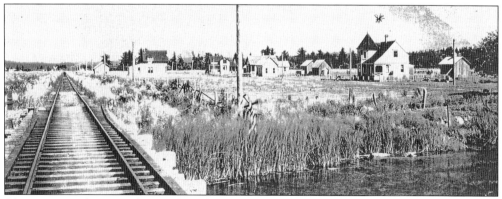
Clara Munson's home can be seen from the railroad tracks. (Courtesy of the Warrenton-Hammond Historical Society.)

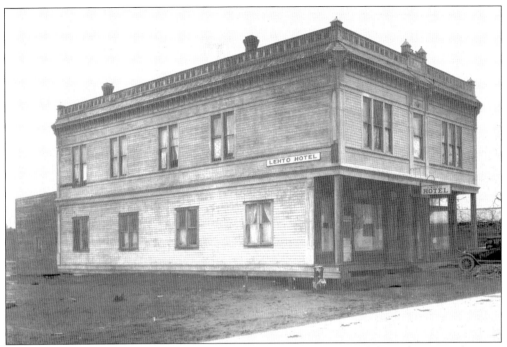

Lehto Hotel was the former Warren's Hall. The building was moved from the original site to just north of Tom Trine's Cigar Store. The Lehto Hotel later burned down. (Courtesy of the Warrenton-Hammond Historical Society.)

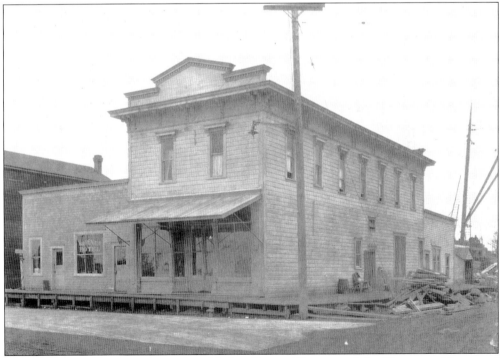

The Warrenton Hotel was located on Harbor Court. (Courtesy of the Warrenton-Hammond Historical Society.)

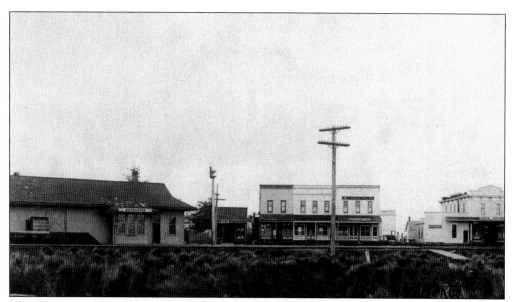

The Warrenton Train Depot stands empty in the foreground with R. J. Abbott's store on the right. There were billiards, pool, cigars, tobacco, fruit, and a confectionery in this block. Children could ride the train from Warrenton to Astoria for 10¢ in 1944. (Courtesy of the Warrenton-Hammond Historical Society.)

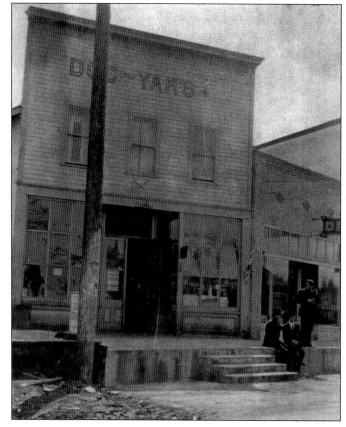

Doc-Yak's (Hendrick) Pool Hall and Card Room had a room upstairs and a barbershop in the front corner. This building burned in 1933. Part of the sign of Wilson's Drug store can be seen next door. (Courtesy of the Warrenton-Hammond Historical Society.)

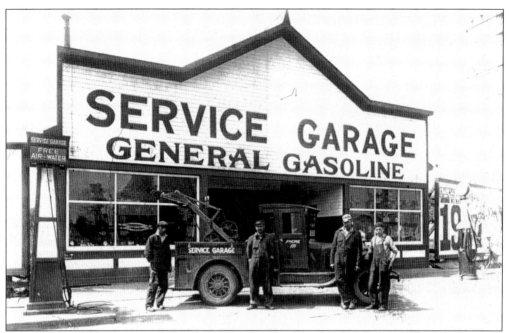

The Service Garage was a place to get air in your bike tires and also where men came to discuss the events of the day. The garage was torn down to make room for the new U.S. Bank building now occupied by the Serendipity Café. (Courtesy of the Warrenton-Hammond Historical Society.)

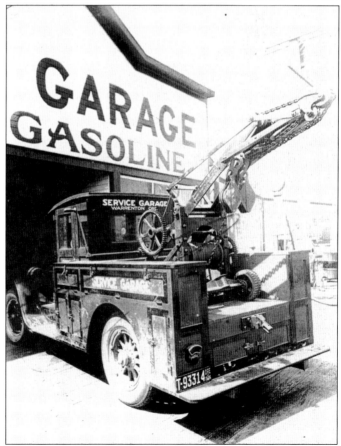

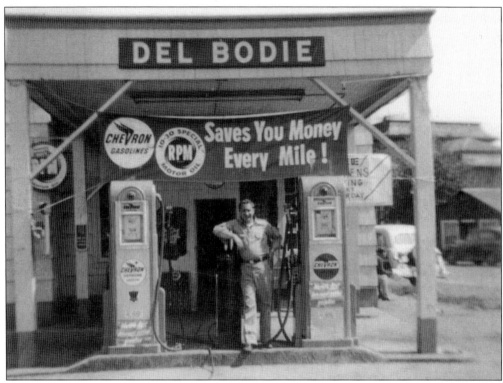

Del Bodie stands between the pumps at his business, Del Bodie's Service Station, located on Main Avenue in the early 1950s. Bill Walker was the original owner. When the gas tank was put into the ground, it rose above the ground the next day so the tank was filled with water and a cement slab was poured to hold it down. Gasoline was 17¢ per gallon in the early 1950s. (Courtesy of the Warrenton-Hammond Historical Society.)

E. R. Baldwin pumped the first gasoline to Fred Hurlbutt, the mail carrier. The post office was nearby before the building was moved to Anchor Avenue. Vic Kaufman was the second owner of Bodie's. He later owned a clothing store in Seaside. Today Bodie's is known as the Clipper Station. E. R. Baldwin became a schoolteacher, coach, school bus driver, principal, and later the city manager. He kept the city budget in the black. (Courtesy of the Warrenton-Hammond Historical Society.)

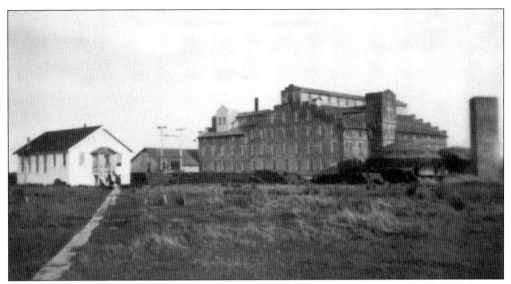

Built about 1917, the Warrenton Clay Company produced sewer pipe, partition tile, flue lining, hollow building blocks, drain tile, and other clay items. The plant was operated by electricity and heated by steam. It was equipped with up-to-date machinery and was rated as "second to none" in the United States, according to their grand opening brochure. (Courtesy of the Bosshart family.)

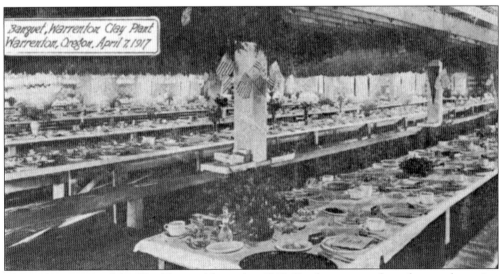

This is the interior of the Clay Plant in November 1918. On the program from the grand opening was written, "A potter, near his modest cot, was shaping many an urn and pot. He took the clay for the earthen things, from beggar's feet and head of kings." (Courtesy of the Warrenton-Hammond Historical Society.)

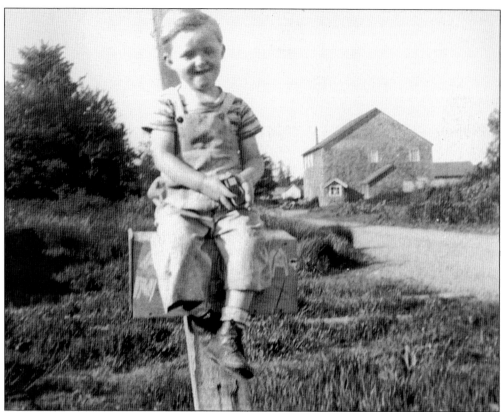

Young Danny Hale sits on a fence post with the International Order of Odd Fellows hall in the background. The building, shown in 1944, is gone but had been where the city of Warrenton trucks are now located. Lumber for the Odd Fellows hall came from the Flavel Hotel. (Courtesy of Charlotte Bergeson.)

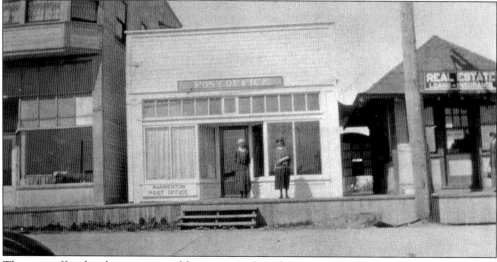

The post office has been in several locations within the town. One location was in a two-story construction that has been moved and is now an apartment building. (Courtesy of the Warrenton-Hammond Historical Society.)

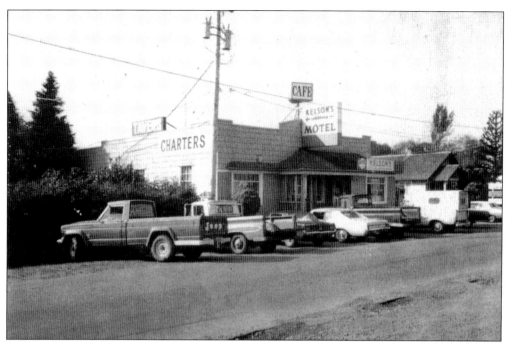

Kelson's, owned by Earl and Ethyl Falconer, later named the Sip-in-on, is now Rod's. There was a tavern, a motel, and fishing charters at this same location. (Courtesy of the Warrenton-Hammond Historical Society.)

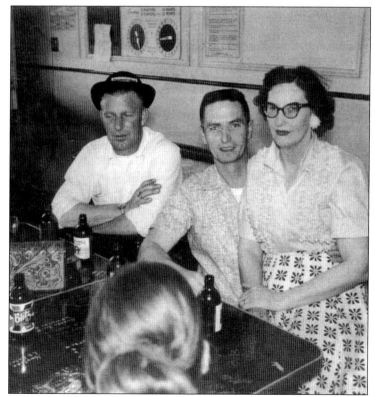

Clockwise from left John Hruby (with hat), Earl and Ethyl Falconer, and Arlene Bailey sit at the counter in Kelson's. (Courtesy of the Warrenton-Hammond Historical Society.)

Arvo Karna, on left, is in front of his shoe shop. The other man is unidentified. (Courtesy of the Warrenton-Hammond Historical Society.)

Arvo Karna and Charlie Laymon, the barber with Jiggles, stand in front of the shoe repair shop. The Karnas lived next to the shoe shop in the same building. Charlie ran the barbershop from 1944 to 1964 at 45 Northeast Harbor Drive. After Charlie's death in 1964, the barbershop became Dale's Beauty Salon and then the location for the *Columbia Press* until they moved to another location. (Courtesy of the Warrenton-Hammond Historical Society.)

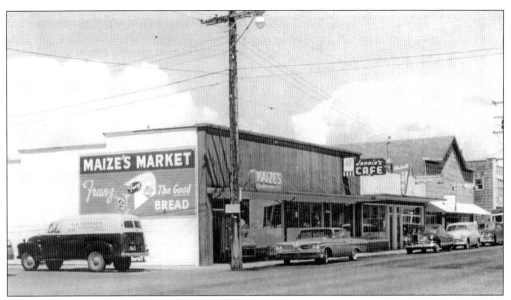

Maize's Market, formerly Maize's Red and White Store, is now Main Street Market located in the same location at 191 Southwest Main Avenue at the corner of Second Street. One door north of Maize's was Jennie's Ice Cream Parlour. Struckrath's Variety Store was between Maize's and an appliance store. It later became part of Main Street Market. The parking lot by the current store was another grocery store. (Courtesy of the Warrenton-Hammond Historical Society.)

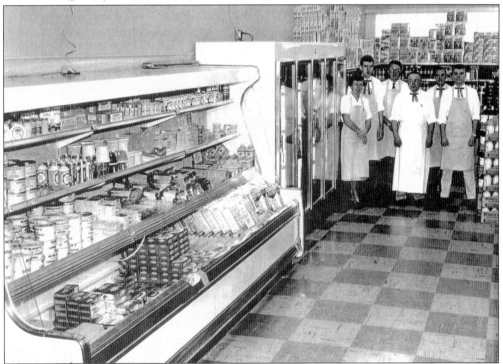

Inside Maize's Market are, from left to right, Elsie Maize, Dick Maize, Frank Maize, Leonard Link, Wayne Sampson, and Buddy Hamilton go about the daily business of store operations. (Courtesy of the Warrenton-Hammond Historical Society.)

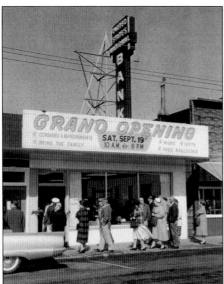

The U.S. National Bank held its grand opening on Saturday, September 19, 1959. (Courtesy of the Warrenton-Hammond Historical Society.)

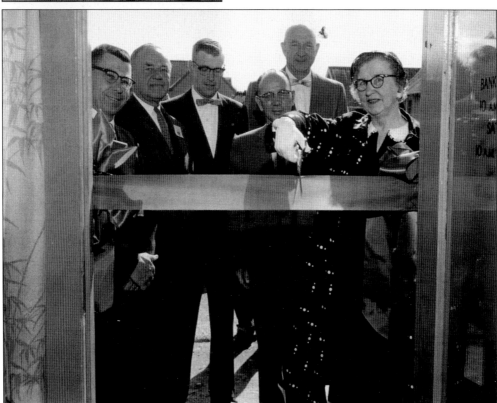

The ribbon cutting was attended by many townspeople. The bank later moved to another building across the street before closing its office in Warrenton. Pictured are, from left to right, Mayor Harold Gramson; E. C. Sammons, president of the U.S. Bank of Portland; John Shepherd, past president of the chamber of commerce; Henry L. Puusti, Warrenton branch manager; E. R. Baldwin, city manager; and Myrtle Niman, president of the chamber of commerce. (Courtesy of the Warrenton-Hammond Historical Society.)

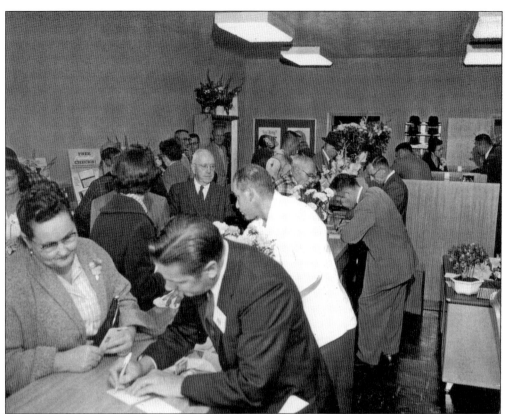

When the doors opened, there was clientele immediately. Notice that all the tellers at the time were male. (Courtesy of the Warrenton-Hammond Historical Society.)

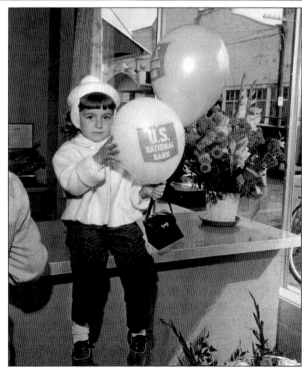

Lorna Hamilton is holding one of the grand-opening balloons. (Courtesy of the Warrenton-Hammond Historical Society.)

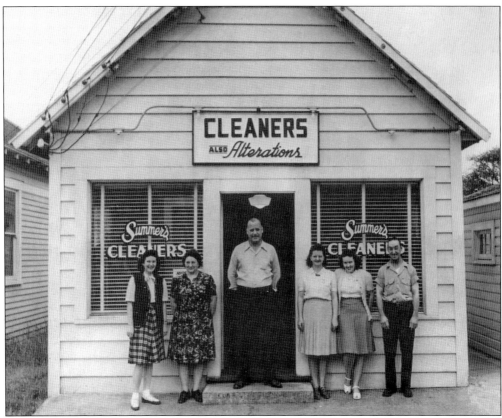

From left to right, Lee Broderick, Pearl Summers, Dick Summers, Eunice Klein, MaryAnn Bosshart, and Al Summers stand in front of Summer's Cleaners. Summer's Cleaners later became Smith's Cleaners and then Faye's Little Hair Shop. (Courtesy of the Warrenton-Hammond Historical Society.)

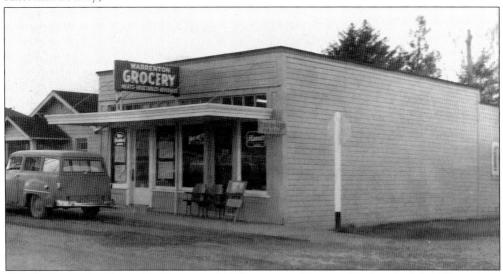

The Corrigans and later the Shaws owned Warrenton Grocery. (Courtesy of the Warrenton-Hammond Historical Society.)

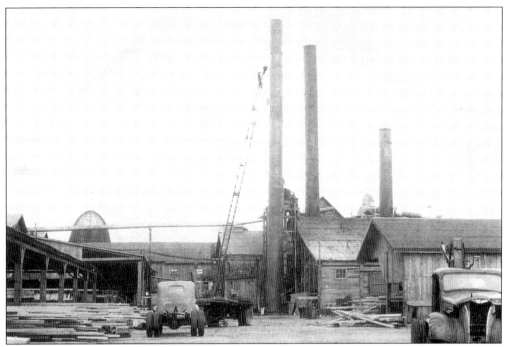

Theodore Dichter went into partnership with Bert, Walter, Arthur, Fred, and Emery Prouty in 1922 to build the Prouty Lumber and Box Company. The mill was in continuous operation until October 1953. In 1956, the Warrenton Lumber Company mill was built on the site of the dismantled Prouty Lumber and Box Company. (Courtesy of the Bosshart family.)

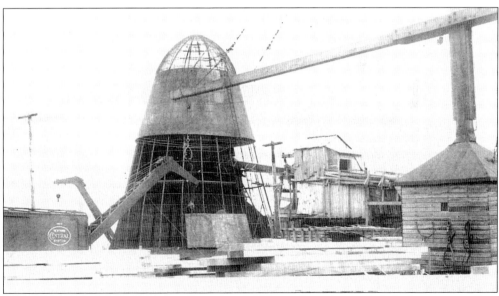

When in operation, the Prouty mill employed 200 people and provided the largest payroll in Warrenton. The wigwam sawdust burner can be seen in this picture. The major product of the mill was dimension lumber. (Courtesy of the Bosshart family.)

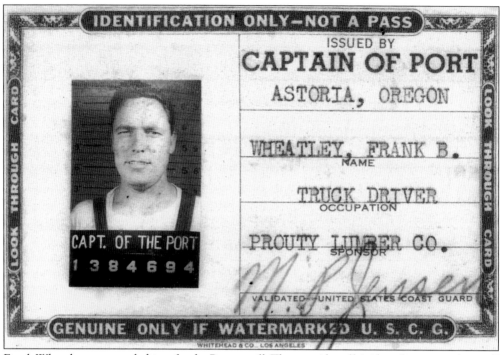

Frank Wheatley was a truck driver for the Prouty mill. The two sides of his identification card give all the information required for his admittance to the mill area. (Courtesy of Cathy Courtwright.)

(back of card)

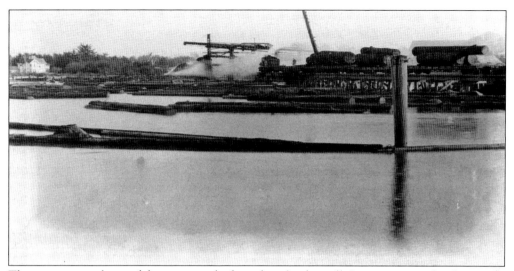

The trains were also used for carrying the large logs for the mill. Logs were stored in large rafts on the river. G. S. P. Company–boom cars are shown at the log dump on the Skipanon River. (Courtesy of the Warrenton-Hammond Historical Society.)

The docks were later used for loading wood when the mills were built in the area. (Courtesy of the Warrenton-Hammond Historical Society.)

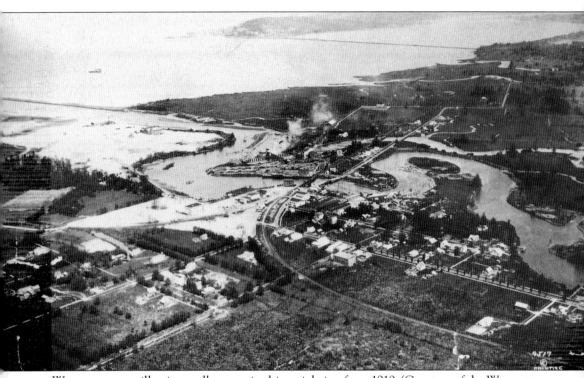
Warrenton was still quite small as seen in this aerial view from 1919. (Courtesy of the Warrenton-Hammond Historical Society.)

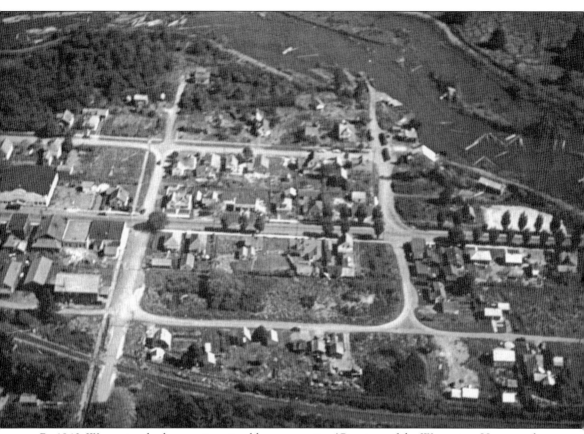

By 1940, Warrenton had grown to a sizeable community. (Courtesy of the Warrenton-Hammond Historical Society.)

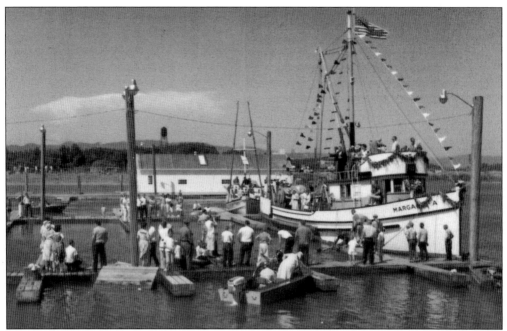

The Warrenton Mooring Basin was dedicated on July 4, 1958. It is still an active marina for fishing and live-aboard boats. This boat belonged to Ted Ames at one time. Governor Holmes was at the dedication. People boarded the boat at Hendrickson's Moorage and motored to the marina. (Courtesy of the Warrenton-Hammond Historical Society.)

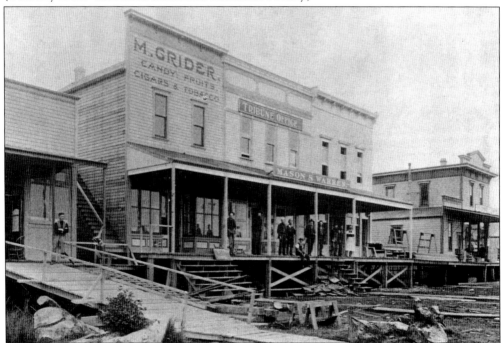

The Mason and Warren Building was the office of the *Tribune* and the M. Grider candy, fruits, cigars, and tobacco store. This picture was taken around 1905. (Courtesy of the Warrenton-Hammond Historical Society.)

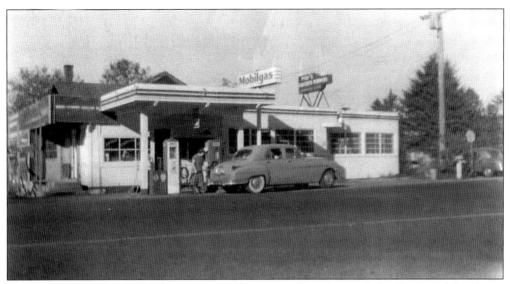

"Pop" Wells owned Pop's Chicken Diner on the corner of Southeast Marlin Street and Southeast Twelfth Street (now Airport Road). This area was also known as Newton's Corners. Later Pop's was moved into downtown Warrenton and sold to the Dunn family. (Courtesy of the Warrenton-Hammond Historical Society.)

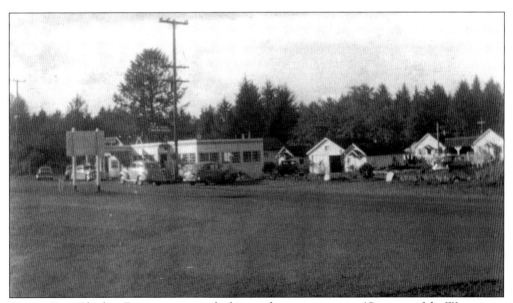

Next to Pop's Chicken Diner was a row of cabins and a service station. (Courtesy of the Warrenton-Hammond Historical Society.)

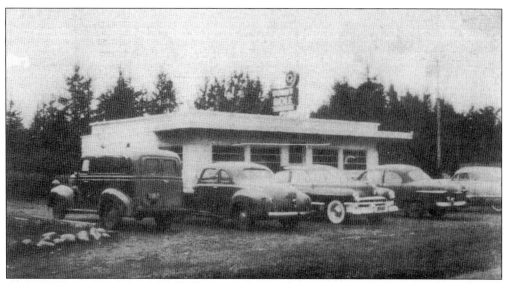

Donut Hole, later known as Carol's Café and the Ponderosa, is now Arnie's Restaurant, located across from the Warrenton High School. The Donut Hole was known as the Seabreeze when it was first built in Hammond. Edwin "Slim" Mowick built the shop for his sister, "Tootsie" Mowick, who moved it to where the mini-mart is in Warrenton and then to the current location. (Courtesy of the Warrenton-Hammond Historical Society.)

Arnie's Restaurant is located in the area that was Lexington. Originally the building was in Hammond and known as the Seabreeze and later the Donut Hole. The building was originally at Fort Stevens and then moved to Hammond and later to its present location across from the Warrenton High School. The building added to the right side of Arnie's Restaurant was a U.S. Air Force bomb station that was also moved from Fort Stevens. (Courtesy of Susan L. Glen.)

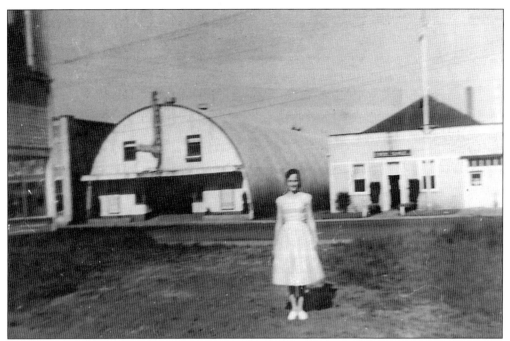

Pictured here is Pat Snively in front of the movie theater in 1958. Movies were not rated at the Warrenton movie theater when it opened. In 1948, the cost for a movie was 15¢, then in the early 1950s, the cost increased to 35¢, and by 1955, the cost was over $1 to attend a movie. A. Clapp and Jim Anderson built the Quonset-hut Theater. (Courtesy of the Warrenton-Hammond Historical Society.)

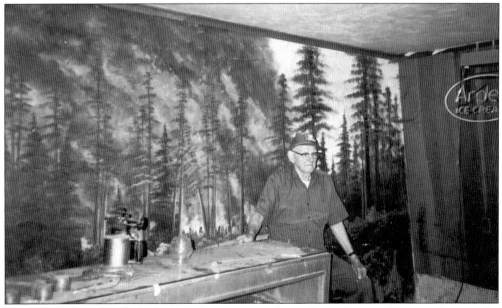

After the theater closed, the building became a warehouse for appliances. This mural was at the east end of the building. It was painted by Mr. Wonsmus and represented the Tillamook burn. Conrad W. Peterson, shown, was the owner of Warrenton Electric, a Hotpoint dealer. (Courtesy of Carolyn M. Shepherd.)

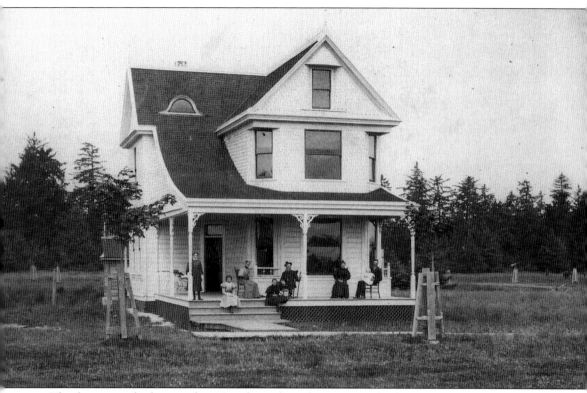

This house was built around 1895 and may have been one of the houses constructed with the $1,000 bonus offered by the Warrens. Warren offered the $1,000 bonus to any man who built a house costing less than $3,000. Any man who built a $3,000 house also received a choice lot for free. Sadie and Homer Hurt came from Kansas and lived here for many years. It is now the home of Jim and Gillian Maggert. Gillian has been the Hammond librarian for many years. The unique "eyebrow" window was removed when the house was reroofed. (Courtesy of the Warrenton-Hammond Historical Society.)

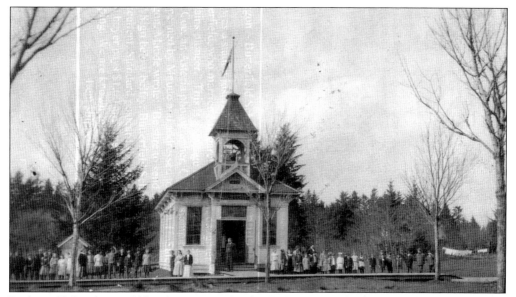

Built at 65 Southwest Alder Avenue in 1892 by D. K. Warren for $1,100 and used until 1915, this was known as "the big school." There was a smaller school building next door that had been constructed previously. On the day the move was made to the new school, the children walked through the woods to 820 Southwest Cedar Street. (Courtesy of the Warrenton-Hammond Historical Society.)

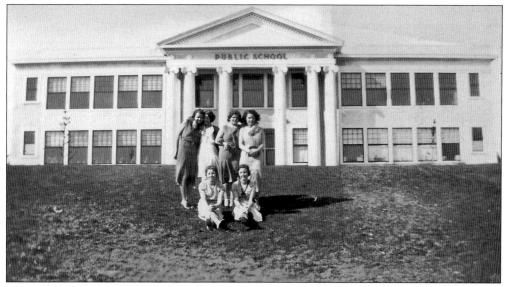

The new building opened on September 26, 1918. J. T. Lee was the principal. The first school bus was purchased in 1924. Posing in front of the Warrenton Grade School in 1932 are, from left to right, (first row) Helen Rowley Hissner, Stella Sigurdson, Roberta Storm Jensen, and Mae Nedry; (second row) Dot West and Kate West. The current grade school was built on the same site as this school in 1979. (Courtesy of the Warrenton-Hammond Historical Society.)

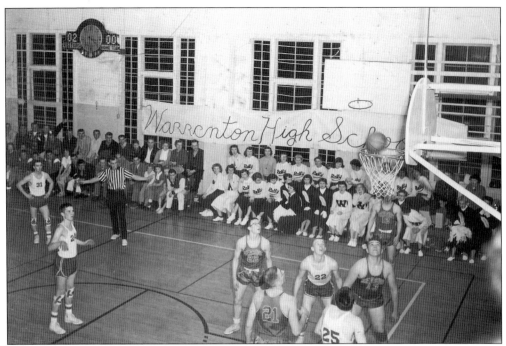

Until the gym was added to the Warrenton High School, the basketball team played its games in the gym at the grade school. (Courtesy of the Warrenton-Hammond Historical Society.)

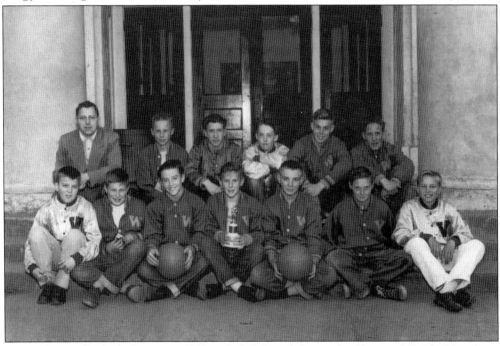

Ron Coleman's basketball team in 1953 included, from left to right, (first row) Bobby Hamilton, George Matteson, Tommy Johnson, Ronny Nedry, Bobby Maize, Fred Wildgrube, and Gary Bergeson; (second row) coach Ron Coleman, Jay Nedry, Marvin Olson, Tommy Carden, Donald Peterson, and Ron Harrington. (Courtesy of the Warrenton-Hammond Historical Society.)

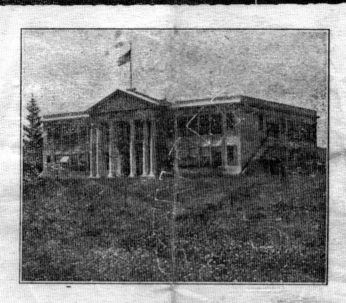

PROGRAM
Commencement Exercises
Warrenton High School
May 22, 1924

PROCESSIONAL	BAND
INVOCATION	REV. WARRELL
VOCAL SOLO	MRS. GEORGE WARREN
SALUTATORY	WILLIAM HAMEL
SONG	H. S. GLEE CLUB
VALEDICTORY	DONALD BEELAR
MUSIC	BAND
COMMENCEMENT ADDRESS	DR. G. R. VARNEY
(Prof. Public Speaking, Linfield College)	
PRESENTATION OF DIPLOMAS	W. C. WICKLINE
PRESENTATION OF CONFERENCE SCHOLARSHIP	L. C. CAMPBELL
MUSIC	BAND
BENEDICTION	REV. WARRELL

This is the commencement program for graduation on May 22, 1924. Warrenton High School was located on the second floor of the building at that time. (Courtesy of Susan L. Glen.)

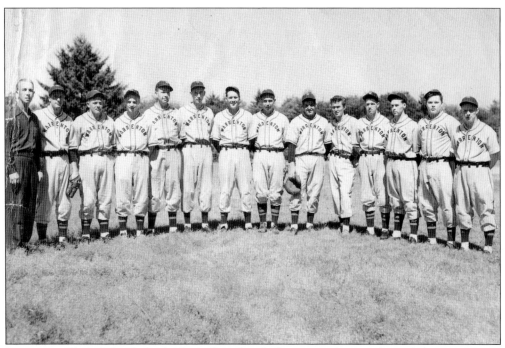

Warrenton High School also had excellent baseball teams. The members of this Warrenton High School team have not been identified. (Courtesy of the Warrenton-Hammond Historical Society.)

Warrenton High School now has a gymnasium, football stadium, and a bus barn. (Courtesy of Susan L. Glen.)

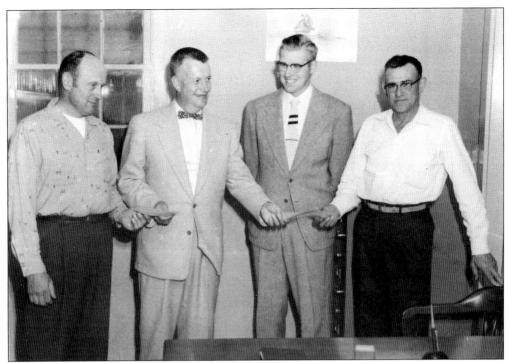

This is a photograph of Warrenton businessmen, from left to right, Dick Ford, Hugh Winstanley, John F. Shepherd Sr., and Conrad Winstanley receiving award checks for promoting all electric homes. (Courtesy of Carolyn M. Shepherd.)

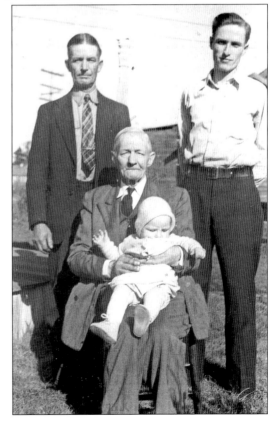

Four generations of the Falconer family sat for this photograph. From left to right, are, (first row) Robert Falconer and baby Diane Falconer; (second row) Earl and Ernest Falconer. (Courtesy of Diane Collier.)

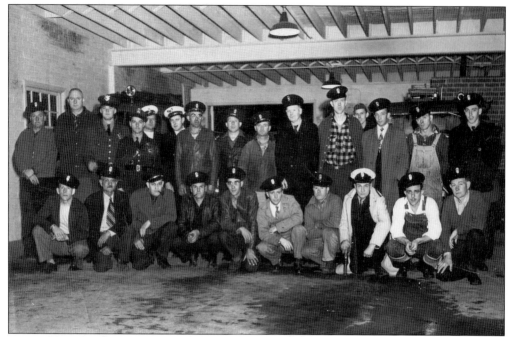

Pictured here is the Warrenton Fire Department crew as seen in 1937. Art Knight was the fire chief, Bill Heppner was acting mayor, G. Clifford Barlow was city manager, and Bill Wallingford was town marshal. (Courtesy of the Warrenton-Hammond Historical Society.)

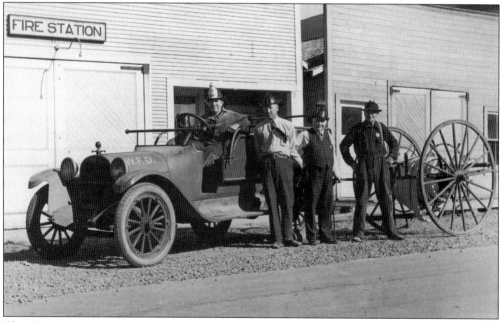

This Stutz pumper was one of the fire trucks operated by the department. The truck was resold to Astoria. Back in the 1920s, the department was caught in the financial crisis of the time and its fire truck was lost. With ingenuity, perseverance, and miscellaneous parts, the department built a fire truck, which served Warrenton for many years. (Courtesy of the Warrenton-Hammond Historical Society.)

The Church of Christ was demolished in 1972. The site had been given to the Warrenton School District by the Warren family in the late 1800s to be used as a school until 1915 when the new school was built. It was then rented out as a family home until 1927 when the Church of Christ rented the building for $25 a year from the school district. In the early years, it was heated by a pot-bellied stove, which was later replaced by an oil heater at the back of the church. (Courtesy of the Warrenton-Hammond Historical Society.)

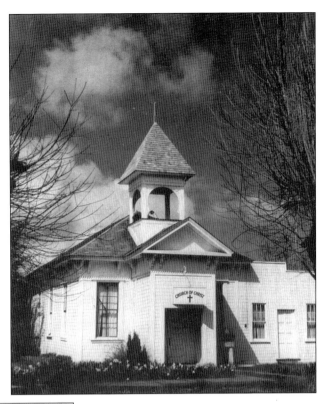

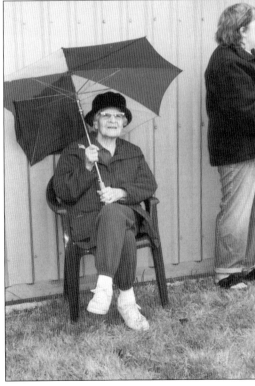

Carolyn Mary Peterson sits under her umbrella in downtown Warrenton. Carolyn and Conrad Peterson owned a farm, Warrenton Electric, and a theater in town. Warrenton Electric sold appliances, gifts, and did electrical contracting. (Courtesy of the Warrenton-Hammond Historical Society.)

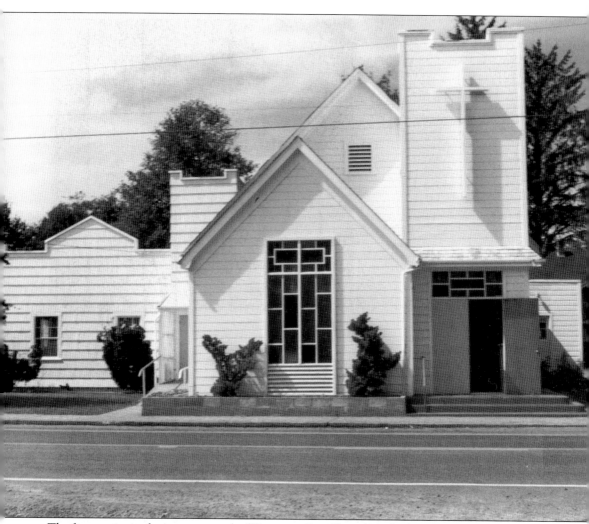

The first service in the sanctuary at the Warrenton First United Methodist Church may have been on June 11, 1893. Prior to this, services were held in private homes. William Ayers was the first pastor of the church. It was originally called Warrenton Methodist Episcopal Church. (Courtesy of the Warrenton-Hammond Historical Society.)

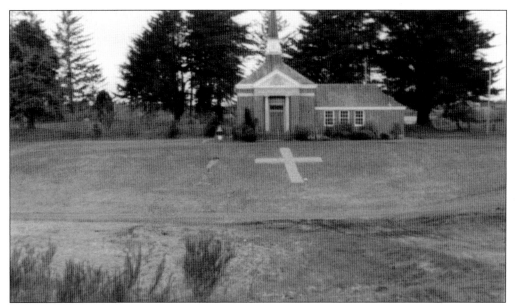

Pioneer Presbyterian Church was the first Presbyterian church to be built west of the Rocky Mountains. Rev. Lewis Thompson was the first minister at the church. He was born in Kentucky in 1809 and came to Oregon in 1845. In 1850, Robert Morrisson gave a "bond deed" of 1 acre for a cemetery and 4 acres for a church. William H. Gray was contracted to construct the first building. The present structure is the third building constructed on the site and was completed in 1929. (Courtesy of Susan L. Glen.)

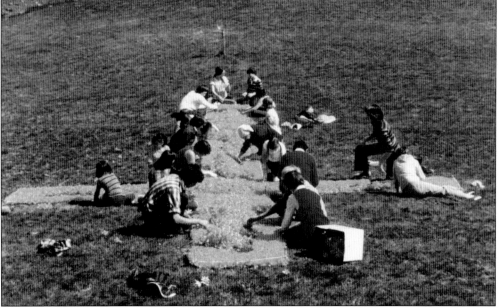

The creation of the daffodil cross began around 1947 and 1948 by Travis Shultz. Members of the church and the local community turned out to pick the blossoms, which were then placed side by side in the grass to form the cross. The daffodils grew all along the fields on Clatsop Plains, but several years ago, the fields adjacent to the church were planted, and the flowers are now grown there. (Courtesy of Susan L. Glen.)

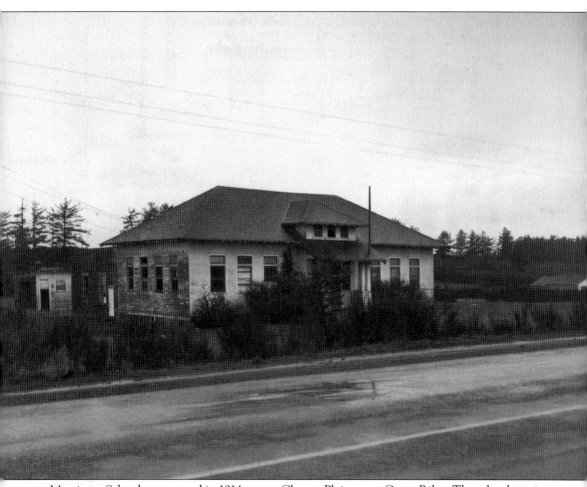

Morrisson School was erected in 1914 out on Clatsop Plains near Camp Rilea. The school was in use until 1948. At first, the building was a two-room school until they took part of the gym and made a third room. Robert William Morrison built the first schoolhouse on that site in 1847. A second building was constructed in 1854, and then the structure pictured was completed in 1914. Pictured on the next pages are students who attended Morrison School. Many of their families are still living in the area. (Courtesy of the Warrenton-Hammond Historical Society.)

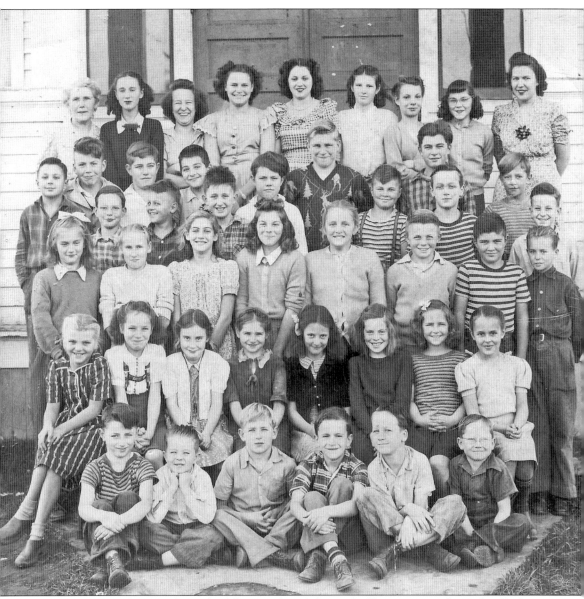

Pictured in this photograph are the following, from left to right (first row, seated): Wesley Shultz, John Keckler, John Stratton, Barry Nelson, Durwood Weaver and Kenny W; (second row) unidentified, Mence, Patty Fraser, Millicent Lamb, Anne Stratton, Juanita Killion, Denise Bartoldus, Rosemarie Stillwell, and Carol Bosshart; (third row) LaVerne Davis, Anna Doney, Leona Thiesen, Marilyn Peterson, Barbara Hundlun, Dick Hansen, Bill Mendenhall, and Kenneth Heckler; (fourth row) Frank Lamb, Tommy Lee, Jay Dye, Keith Mendenhall, Donald Fraser, and Asher Hamilton; (fifth row) Jack Beachill, Ted Zinn, Dick Williams, Wallace Huffersmitz, Bill Williams, Keith Dyer, Donald Baker, and Billy Killion; (sixth row) Mrs. Lola Bartoldus, Barbara Jean Wallace, Lily Weaver, Dorothy Atkins, Varnor Bridges, Devine Erikson, Dorothy Stanwood, Evelyn Wheatley, and Miss Bessie Bartoldus. (Courtesy of Anna Stratton Jensen.)

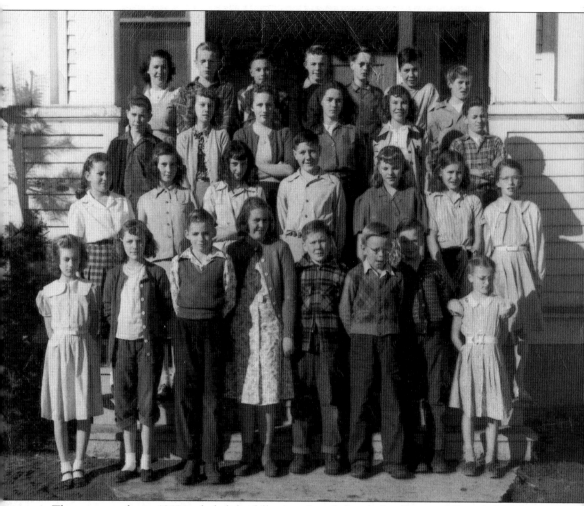

The upper grades in 1949 included the following, from left to right: (first row) Beverly Hutchins, Joan Yuill, Dewayne Buffington, Anita Glousha, John Nieman, Eino Ritla, Monte Koski, and Judy Shultz; (second row) Nancy Martivich, Milicent Lamb, Juanita Killion, George Barrells, Thelma Mence, Anna Stratton, and Katherine Hurgland; (third row) Norman Johnson, Loisann Templeton, Barbara Hurgland, Rae Heaton, Helen Atkins, and Asher Hamilton; (fourth row) Bessie Justin, Edwin Ritila, Jack Beachill, Dick Hansen, Frank Lamb, Ted Zinn, and John Stratton. (Courtesy of Anna Stratton Jensen.)

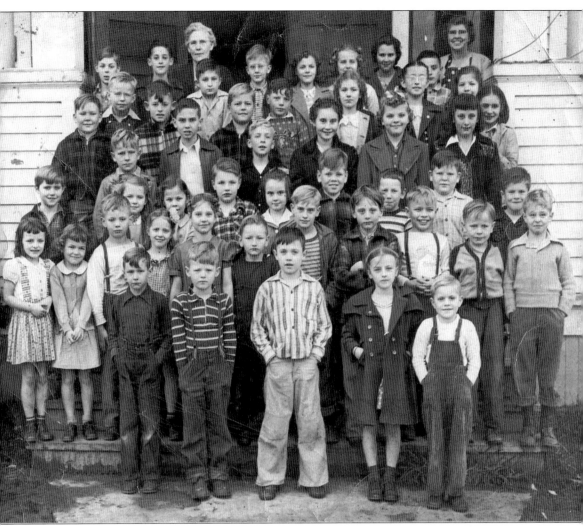

Pictured here are intermediate and primary students attending the school in 1947 and 1948. From left to right, the following are: (first row) Ray Stilwell, Jerry Sigurson, Steven Mason, Judy Shultz, and James ?; (second row) Jennie Shultz, Linda-, Billy Heaton, Rosemarie Lacher, Eleanor Lacher, Daniel ?, George Thieson, Buddy Killion, Sidney Shaffer, Teddy Ritla, and Billy Cline; (third row) Harvey Stratton, Theresa King, Judy Depping, Jimmy Cox, Marilyn Lamb, Glen Matthews, Loring Trombo, Jerry Neiman, and Billy Berg; (fourth row) Donald Ritla, Jerrold Sutton, John Stanley, Milicent Lamb, Thelma Mence, and Juanita Killion; (fifth row) John Neiman, Raymond Sigurson, Jerry Coachan, and Anna Stratton; (sixth row) Eino Ritla, Billy Weidmer, Allen Slyter, Beverly Hutchins, Katherine Hurgland, and Joanne Brim; (seventh row) Dan Peterson, Charles Thieson, Mrs. Lola Bartoldus, Monty Koskia, Joan Yeull, Deanna Ekstom, Anita Goulsha, Dick Hayes, and Mrs. Mary Morse. (Courtesy of Anna Stratton Jensen.)

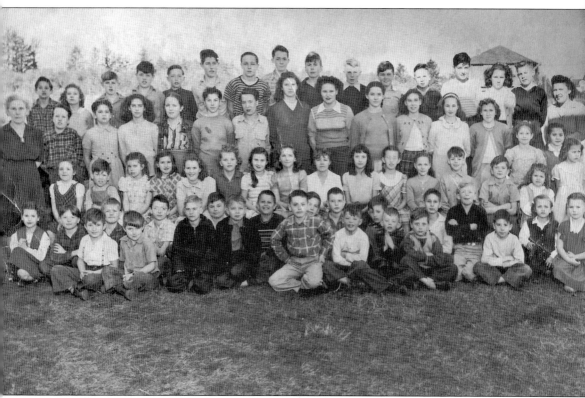

This photograph shows, from left to right, (first row) Sandra Chaney, Allen Slyter, Billy Wiidmier, Jerry Chochane, Harvey Stratton, Thesley Shultz, George Thiessen, Keith Mendenhall, Sidney ?, Tommy Lee, Dickie Hayes, Asher Hamilton, Fritz Larsen, Frank Lamb, Billy Heaton, Raymond Sigurson, Buddy Killion, Jerry Larson, Donald Chaney, Judy Shultz, Theresa King, and Marilyn Lamb; (second row) Ida ?, Glen Matthews, Phylis Bentley, Anna Stratton, Anita Golusha, Thelma Mense, Millicent Lamb, Rosemarie Stillwell, Shirley Atkins, Juanita Killion, Katherine Hendlen, Joan Y, Donny Peterson, Bobby Killion, Linda ?, and Judy Depping; (third row) Mrs. Lola Bartoldus, Durwood Heaner, Jessie Bridges, Leona Thiesen, Barbara Hurdin, Marilyn Peterson, Lily Weaver, Devine Erikson, Dorothy Atkins, Rae Heaton, Helen Atkins, Deloris Bowers, Anna Doney, Eleanor Lacker, and Janice Fraser; (fourth row) Charles Thiesen, Beverly Hutchins, John Stratton, Bill Williams, Bill Killion, Dick Williams, Don Fraser, Larry Harchberger, Ted Zinn, Dick Hansen, Neil Mendenhall, Jack Beachill, Wallace Huffersnitz, Patty Fraser, Jimmy Townsend, and Miss Bessie Bartoldus. (Courtesy of Anna Stratton Jensen.)

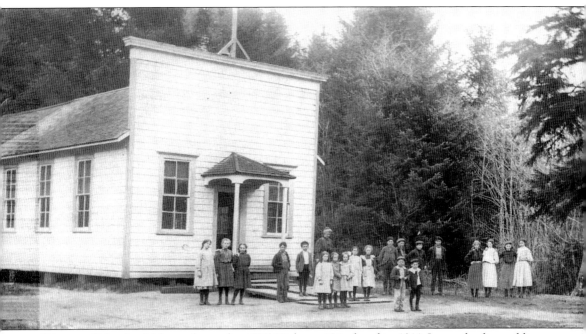

Skipanon School, which was located at 1895 Highway 104, closed in 1914. It was the first public school in Warrenton but was located in the village of Skipanon in 1867. Miss Emma Hess was the first teacher. She was paid $50 per month. The logs for the school building came from the sawmill built on the Wahanna River in Seaside by Robert W. Morrison. Solomon H. Smith opened a store in Skipanon and also owned one of three warehouses at Lexington. Both towns were in the same general area where Warrenton High School is today. There was also a blacksmith shop, several dwellings, and a hotel in the same area. Lavern Jurhs is standing on the far right. She is the grandmother of Diane Collier and daughter of Kate Jurhs. (Courtesy of the Warrenton-Hammond Historical Society.)

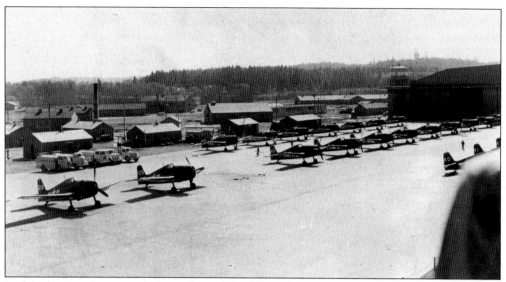

In this photograph are naval planes during World War II on the tarmac at Astoria Airport located in Warrenton. (Courtesy of the Warrenton-Hammond Historical Society.)

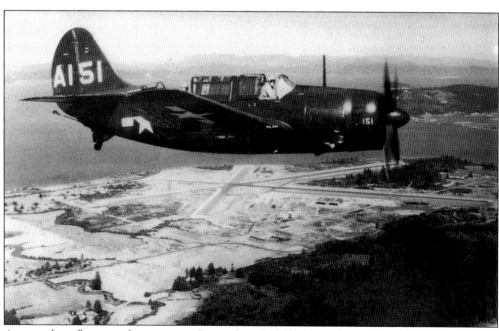

A navy plane flies over the airport in September 1945. The U.S. Coast Guard now maintains an air station at the airport. (Courtesy of the Warrenton-Hammond Historical Society.)

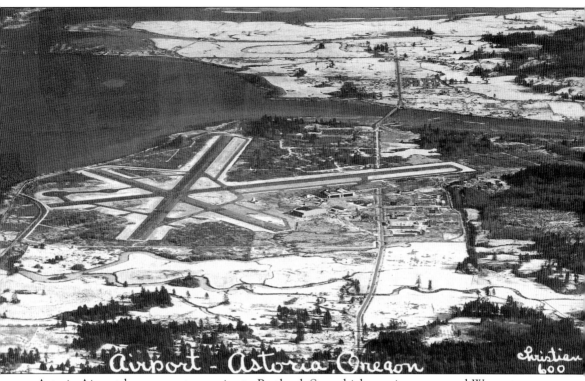

Astoria Airport has commuter service to Portland. Some highway signs now read Warrenton-Astoria Airport. The bridge crosses Youngs Bay to connect Warrenton with Astoria. The larger body of water is the Columbia River. (Courtesy of Susan L. Glen.)

MEMBER AMERICAN CAMPING ASS'N.

CLATSOP GIRL SCOUT COUNCIL
ASTORIA, OREGON

Camp Kiwanilong

1959

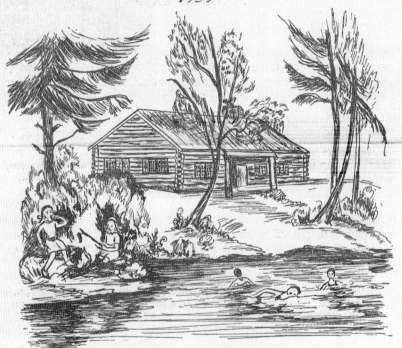

ASTORIA KIWANIS CLUB
YOUTH PROJECT

CAMP DATES AND FEES

CAMP LIVING

Camp Kiwanilong is located off Ridge Road in Warrenton near Fort Stevens State Park. Camp Kiwanilong was a Girl Scout camp from 1936 until 1975. The camp is now open to all youths. The name is a combination of Long Lake, on which it is located and Kiwanis for the Astoria Kiwanis who were responsible for the funds and supplies to construct the buildings. The camp includes 270 acres and offers a variety of activities.

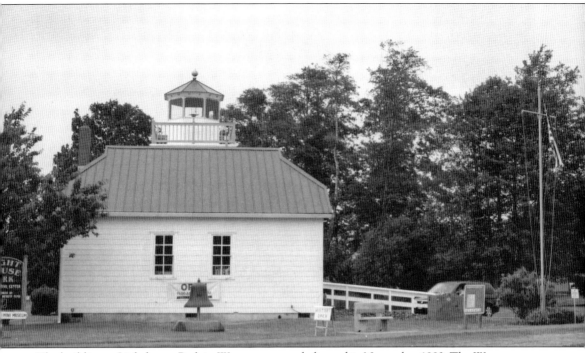

The building at Lighthouse Park in Warrenton was dedicated in November 1993. The Warrenton-Hammond Historical Society Museum, begun in May 1998, is located in Lighthouse Park. The interpretive center contains artifacts from many of the industries that have been in the area and a great collection of pictures. The large bell was donated by the U.S. Coast Guard. Next to the building is a memorial to the men and women who worked in the fishing industry. Volunteers staff the center, which is open from Memorial Day to September 15th, and the hours are 11:00 a.m. to 4:00 p.m. (Courtesy of Susan L. Glen.)

www.arcadiapublishing.com

Discover books about the town where you grew up, the cities where your friends and families live, the town where your parents met, or even that retirement spot you've been dreaming about. Our Web site provides history lovers with exclusive deals, advanced notification about new titles, e-mail alerts of author events, and much more.

Arcadia Publishing, the leading local history publisher in the United States, is committed to making history accessible and meaningful through publishing books that celebrate and preserve the heritage of America's people and places. Consistent with our mission to preserve history on a local level, this book was printed in South Carolina on American-made paper and manufactured entirely in the United States.

This book carries the accredited Forest Stewardship Council (FSC) label and is printed on 100 percent FSC-certified paper. Products carrying the FSC label are independently certified to assure consumers that they come from forests that are managed to meet the social, economic, and ecological needs of present and future generations.

Mixed Sources
Product group from well-managed forests and other controlled sources

Cert no. SW-COC-001530
www.fsc.org
© 1996 Forest Stewardship Council

Find Your Place in History.